MANGA
CHARACTER DESIGN

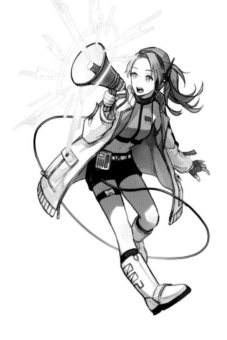

SHUN AKAGI

TUTTLE Publishing

Tokyo | Rutland, Vermont | Singapore

CONTENTS

Case Studies

I'm depressed!

Can you take a look at my illustration? I'm a little worried about it!

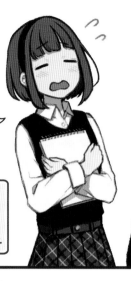

Yes, of course!

Koki
A student at an illustration school studying to become a manga artist and animator.

Ms. Kobayashi
A professional illustrator who also works as an instructor at an art school.

This is it.

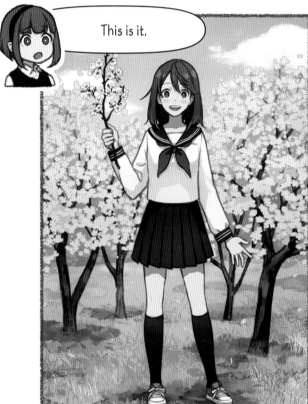

I think you did a good job. What is it that's bothering you?

How do I say this?

The image didn't turn out exactly as I'd expected.

Image?

What made you want to draw this character?

My initial inspiration?

Well, the other day, while wearing a cherry blossom corsage, I happened to see a couple a middle school students.

I thought, maybe I can combine the two elements in a fresh way.

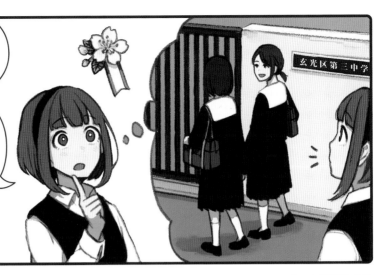

I wish I could convey cuteness and charm in illustration form.

In other words, were you worried about not being able to represent the image you wanted to capture?

Yeah, it seems so.

I just wish I could draw better ...

But you don't necessarily have to draw well, now do you?

What?!

If you don't have a clear sense of the character you want to create, the results can be disappointing.

Even using the same generic description, such as "girl in a sailor suit," if the character design and mode of expression are changed, the result will be completely different.

Variations on a Theme

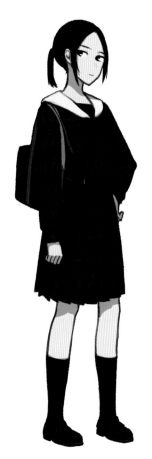

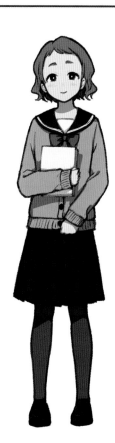

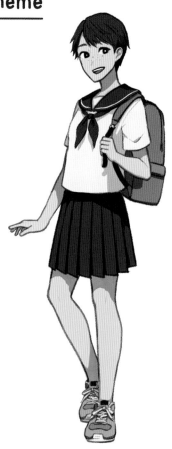

Serious and cool, yet dignified

Likes to read and seems to be easy-going

Cheerful and athletic, up for anything

So if I meld my character design with my style and modes of expression, will the result be what I imagined?

Let's try it!

Let's start with the character design.

The image you want to express is innocence, the freedom of youth. Is that right?

Exactly!

Original Design

Her hairstyle and skirt length give her a more lively, mature look.

Brighter hair color or splayed ends

Short skirt length

Well-worn sneakers.

A More Tailored Look

Giving the design a fresh reinvention.

A darker hair color, while the short bangs make her look a little younger.

The body is emphasized by making the uniform slightly larger.

Here the skirt is lengthened.

Add a school bag for visual variety.

The shoes should be brand-new loafers.

How about a design like this?

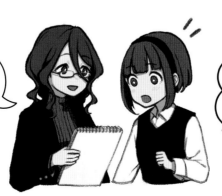

Wow, when I first sketched the character, I didn't think about it in such detail!

Next, we're going to focus on how the character's depicted,

the ways we stage and "showcase" the persona.

It's about how to make the designed character appealing!

For example, facial expressions, gestures, poses, framing and angles, colors, the use of light and shadow—just for starters!

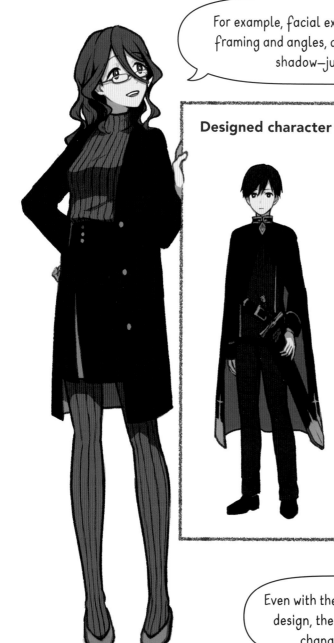

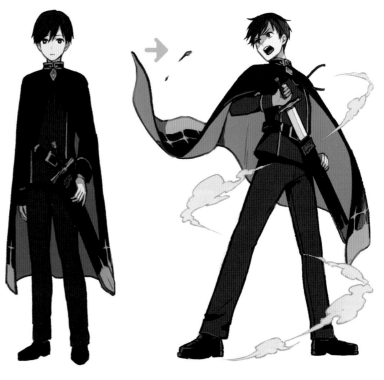

Designed character

Innovative methods of expression

Even with the same character design, the impression can change, can't it?

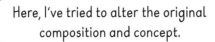

Here, I've tried to alter the original composition and concept.

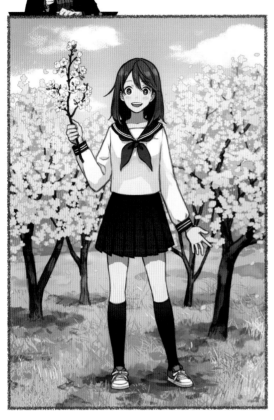

Original Illustration

A high school girl is hanging in the park holding a cherry blossom branch, and a friend with her took a photograph of the scene.

Expression aligned with the image

Now she's looking up at the blossoms in front of the school. I used a bird's-eye perspective so her expression can be more clearly seen. I conveyed a sense of freshness and translucence with the light touch in the coloring.

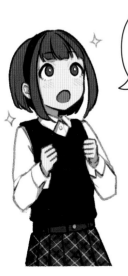

It's totally different from the first illustration, isn't it? With this, the intended image seems to come across!

If we have a specific image we want to convey, we have to be creative to make sure it gets communicated properly, right?

The Character Production Process

It's time to create compelling characters and then set them in motion in the stories you want to tell.

Decide on the theme you want to express

Based on what you like and your own worldview, determine what you want to express in your illustration and the theme you wish to convey.

It's O.K. to start with vague notions or generalities, such as "I want to use a specific color scheme" or "I want to create a lively crowd scene."

Character Design ▶ CHAPTER **1**

Based on the theme, design a character that matches and conveys it. Design input is key, leading to a more detailed and developed persona. In Chapter 1, we'll look at elements of character design and expression.

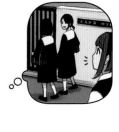

Expression & Composition ▶ CHAPTER **2**

Capture and express your theme by adding facial expressions and poses to your character, and by choosing a composition and color scheme that match the overall look and image. In Chapter 2, we'll explore ways of creating compelling, refined characters.

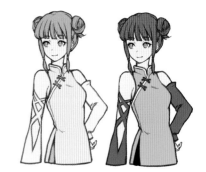

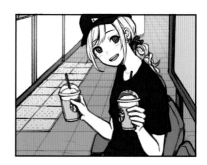

Case Studies ▶ CHAPTER **3**

Character design and modes of expression are explained in a series of detailed case studies, each reflecting a different directive or goal.

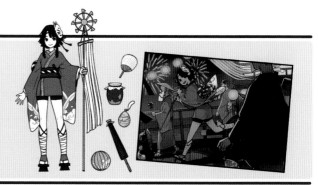

The illustrations in this book were created using CLIP STUDIO PAINT EX (Version 1.11.2), and the explanations follow accordingly.

CHAPTER **1**

Character Design

In this chapter, it's all about character creation: facial features, body size, hair, clothes and the color scheme to convey it all. These are the keys to developing indelible and unforgettable manga and anime characters!

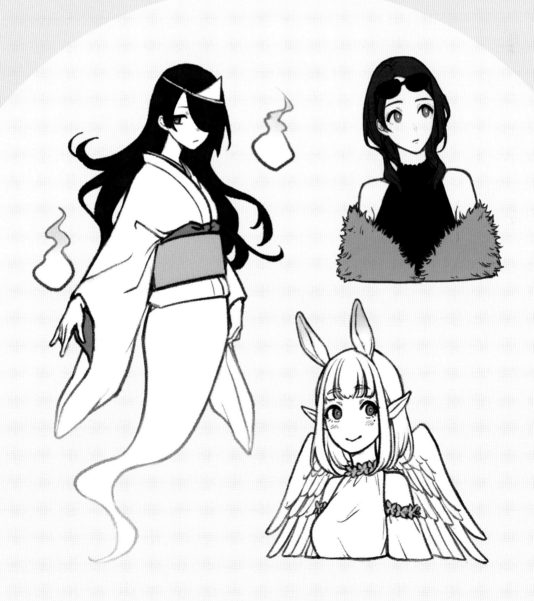

Body Shape

Choose a body shape and size that convey the image and impression of the character you want to create. This is the blueprint of the finished creation to come.

⬒ Body Shape By Gender

There are several significant differences between traditionally gendered male and female bodies. By capturing the various features and details, you're opening your characters to an even wider range of self-expression.

Traditional Male and Female Physiques

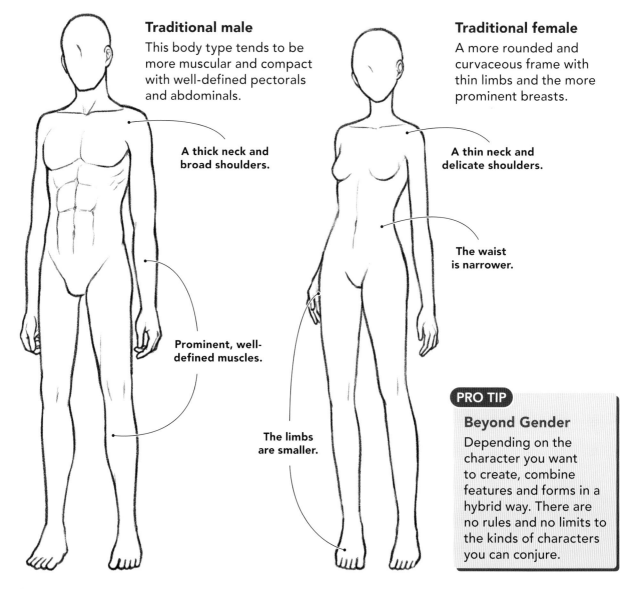

Traditional male
This body type tends to be more muscular and compact with well-defined pectorals and abdominals.

A thick neck and broad shoulders.

Prominent, well-defined muscles.

Traditional female
A more rounded and curvaceous frame with thin limbs and the more prominent breasts.

A thin neck and delicate shoulders.

The waist is narrower.

The limbs are smaller.

PRO TIP

Beyond Gender
Depending on the character you want to create, combine features and forms in a hybrid way. There are no rules and no limits to the kinds of characters you can conjure.

Body Shape and Age

Our bodies change as we age. By reflecting certain characteristics in your designs you can easily indicate your character's physical age, stature or level of maturity. Characters of a similar age can be given a wide range of physical distinctions.

Life Cycle & Stages of Life

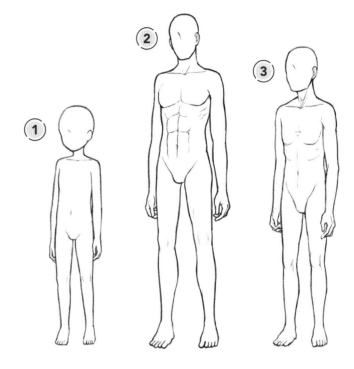

① Childhood
A slightly large head relative to the body. There aren't many muscles present, and the lines are soft overall.

② Adolescence
Moderately muscular and well-built.

③ Old age
The body can appear bonier and more shrunken and exhibit a curved spine.

Postures & Poses

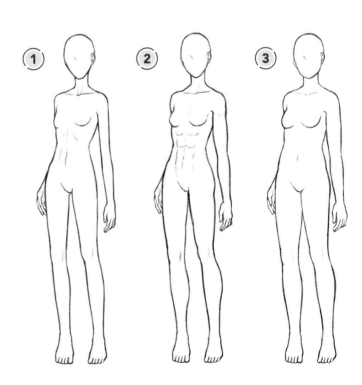

① Lean/Lanky
Weak, sickly, quiet, shy, demure

② Muscular
Strong, robust, healthy, energetic, cheerful

③ Fuller-framed
Gentle, loose, relaxed, slower paced

The Head and Body

The proportions used here refer to the ratio of head length to height. Alter and play with these proportions accordingly to highlight a character's age, stature or other attributes that are key. Familiarity with a range of forms is especially useful for fantasy-themed manga.

☰ General Proportions

Usually, as we age and progress from child to adult, our physical proportion increase. However, there's no need to stick to typical proportions. You can adjust the frame, shape or size to match the image and physical presence of the character you want to depict. A character's impression and impact change when using different proportions, and when multiple characters occupy the same space or scene, the differences emphasize each one's unique qualities.

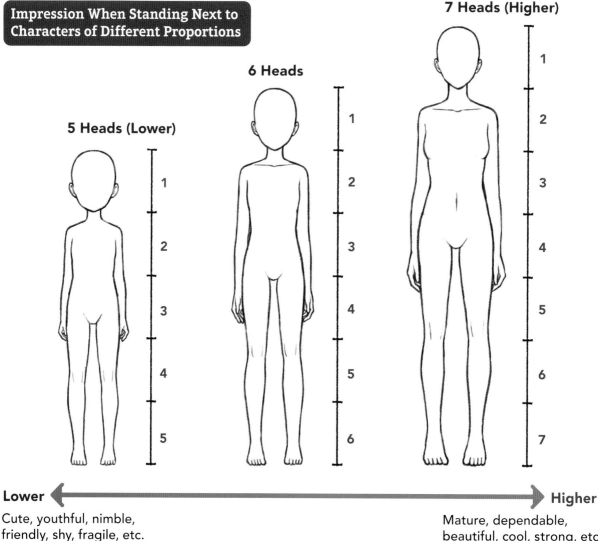

Impression When Standing Next to Characters of Different Proportions

7 Heads (Higher)

6 Heads

5 Heads (Lower)

Lower ← → Higher

Cute, youthful, nimble, friendly, shy, fragile, etc.

Mature, dependable, beautiful, cool, strong, etc.

Proportions Aligned with Character Attributes

In fantasy settings especially, characters might have extreme or shorter proportions. Distinguishing proportions according to a character's attributes can indicate their role and suggest their identity more clearly. Add unseen details. Here, we're using a fantasy hero and his ragtag band as an example.

Roles and Characteristics Expressed Through Proportions

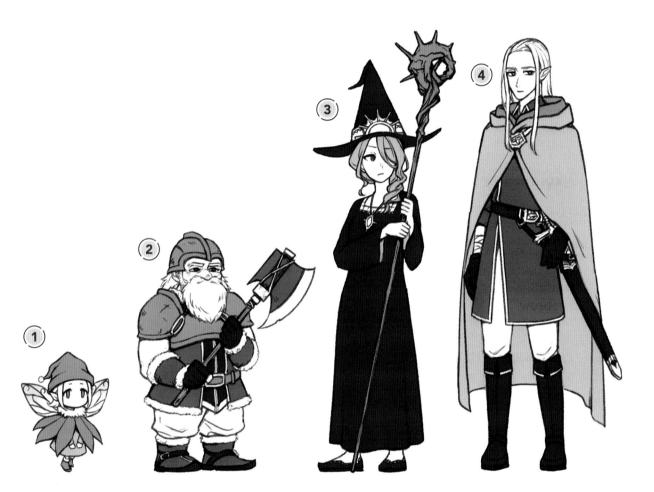

① Fairy (2.5 Heads)

Though small and not very strong, they move nimbly and quickly. They tend to be fearful when facing large foes. Still, their diminutive stature can belie great strength.

② Dwarf (4 Heads)

With their short stature and muscular build, they give off a sense of stability and weightiness. Even if they look tough, these proportions make them appear somewhat cute. They play comedic roles.

③ Witch (6 Heads)

Taller than the dwarf, giving them a stylish and beautiful appearance. By having slightly shorter proportions than an elf, they also exude a feminine cuteness. They fit the heroine role.

④ Elf (7.5 Heads)

Compared to other characters, their taller proportions express a commanding and cool vibe. Rather than fighting with strength, they overwhelm foes with agility.

The Face

The face telegraphs emotion and gives your characters distinction and definition. Considering the shape, size and position of each feature is key, as collectively, they suggest and influence the character's personality.

⊜ Elements Constituting the Face

Each facial feature has its own unique shape, influencing the overall, unified impression your character makes. Mix and match parts according to the desired personality and look you want to create.

Types of Facial Structures and Their Impressions

Round face
Cute, youthful, soft.

Inverted triangle
Cool, beautiful, intellectual.

Base shape
Generous, serious, intense.

Eye & Eyebrow Types and Impressions

Soft eyebrows & slender eyes
Soft eyebrows give a cute, look. Slender eyes imply a laid-back, easy-going presence.

Straight eyebrows & droopy eyes
Straight eyebrows look cool, stylish. Droopy eyes suggest a gentle, relaxed nature.

Thick eyebrows & round eyes
Thick eyebrows convey energy, and strength. Round eyes seem naive or cute.

Nose & Mouth Types and Impressions

Small nose & cat-like mouth
A small nose anchors a friendly face. A cat-like mouth indicates a carefree, optimistic character.

High nose & thick lips
A high nose suggests beauty or nobility. Thick lips appear mature, or sultry.

Low nose & small puckered mouth
A low nose looks youthful, while a puckered mouth reads as easygoing or mischievous.

⬛ Flexible Features and the Aging Face

The key features (eyes, noses and mouths) can be endlessly varied and form captivating combinations. Age can also be conveyed by varying the size, position and contours of the features. As faces age, characteristics like wrinkles, hollowed cheeks and sagging contours can be added.

Eyes, Noses & Lips

Case Study 1
Eyes tend to be narrow with monolids. Noses are typically lower.

Case Study 2
Eyes are closer together. There are pronounced cheekbones, and noses are higher.

Case Study 3
Eyes are large with double eyelids. Eyebrows are distinct, and lips tend to be thicker.

Facial Features by Age

Children
Face has rounded contours, and the forehead is broad.

Adults
Compared to children, contours are somewhat sharp. The distance between the eyes and nose increases.

Elderly
Compared to adults, cheekbones are more pronounced, and facial contours are sharper. Cheeks tend to sag.

💡 **A Bit of Advice**

Expand the range of eye designs
Varying the shape of the eyes for your characters can greatly alter their individual impressions. It's recommended for those not yet accustomed to drawing distinct character faces.

Typical eye shapes

Droopy eyes | Upturned eyes | Cat eyes | Glaring eyes | Whites showing | Slender eyes

Differences in pupil size and shape

Differences in pupils & highlights

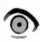 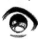

Differences in eyelids

Differences in eyelashes

17

Hairstyles

The impression of the same face can change significantly depending on details like hair length and the direction of the hair tips. A character's hairstyle sets them apart and can offer insight into their character and personality.

☰ Hair Length and Details

With hairstyles, the main consideration is length. Short hair can give an active impression, while long hair pairs well with mature, calm characters. Once the general framework, shape and style are decided, then you can go back and adjust the finer details.

Hair Length and the Impression Given

	Short	Medium	Long
Women	Boyish, cool, active, sporty.	Cute, youthful, energetic, bright.	Neat, beautiful, mature, sensual.
Men	Active, passionate, energetic, sporty.	Fresh, natural, serious, intellectual.	Mature, sensual, fashionable, delicate.

Direction of Hair Tips and the Impression Given

Outward curl
Energetic, active.

Straight
Neat, reserved.

Inward curl
Gentle, adorable.

Position and the Impression Given

High position
Energetic, active, young.

Medium height
Serious, bright.

Low position
Reserved, shy.

Character and Situation Conveyed by Hairstyle

It's good to consider and develop the hairstyle based on the character's lifestyle, whether they prioritize appearance or practicality, for example. Consider factors influencing the hairstyle like the setting, world view and environmental factors such as the season.

Hairstyle, Character and Setting

Messy hair due to bed head
Suggests a casual, sloppy or free-spirited presence. It can fit situations like just waking up, staying up all night or leading a hedonistic lifestyle.

Complicated hairstyle that seems time-consuming
A good look for characters concerned with appearance and with the skill to pull off this complex look.

Characteristic Facial Elements

To emphasize a character's individuality, elements like skin color or features like moles can be effective additions. If there are multiple characters, you can also highlight the similarities or differences between them.

 ## Skin Color and Facial Features

By adding elements to the face, you can accentuate its uniqueness. Consider the skin tone or add features like freckles. For relationships like parent-child or siblings, you can incorporate similar elements to highlight commonalities.

Examples of Added Elements

Original design

Color change and added features

For the character of a frail boy, the skin tone was changed to a pale hue with a bluish tint. Due to the overly simple design, dark circles under the eyes and freckles were added.

Skin Tone

Consider the skin tone in accordance with the character's personality and environment. The basic palette is just a starting point. For fantasy characters or any persona, you can use a rainbow of hues!

Skin Color and the Impression Given

Pale

Neat, translucent, delicate, frail, serious, reserved.

Olive

Ordinary, normal, cheerful, healthy, warm, homey.

Brown

Energetic, active, sporty, positive, health-conscious.

Pale & sickly

Unhealthy, frail, mysterious or a non-human species.

Distinctive Features

To bring the design closer to the character you initially envisioned, consider adding distinctive features. For a traditionally rugged male character, maybe add a beard. For a shy young girl, perhaps give her flushed cheeks. If a design feels incomplete, experiment with the range of features and options.

Various Features and the Impression Given

Mole
Mature, sensual, charming.

Beard
Rugged, hip, stylish, urban.

Freckles
Rustic, natural, fresh-faced.

Flushed cheeks
Cute, gentle, shy, embarrassed.

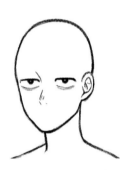

Dark circles under eyes
Unhealthy, studied, frail.

Fanged
Mischievous, wild, playful.

Two-colored
Mysterious, special, delicate, alien.

Makeup/Face paint
Creative, artistic, sacred.

Scars/Stitches
Rugged, strong, dangerous, emotional.

Band-aid
Mischievous, energetic, prankster.

Piercing
Cool, edgy, fashionable, offbeat.

Tattoo
Cool, strong, scary, edgy.

Basic Body Design

Distinctive Body Parts

Especially in fantasy, adding parts to the body such as wings, horns or tails can emphasize a character's individuality and make their identity and backstory clearer to the audience.

Body Part Elements

Adding distinctive parts can certainly amplify the fantasy element of your creations. But it's important to integrate them into the character's overall appearance and the world he, she or they occupy.

Type of parts

Wings, horns and tails: use non-human appendages and features. By showing their shape and texture, you can convey the nature of the creature and the character's background.

For instance, even for an angel, by incorporating rabbit ears instead of a halo, you can achieve a unique design.

Number and position of parts

The number and placement of the parts can express a character's individuality. Even when drawing multiple characters of the same species, you can differentiate each character by varying these aspects.

Even if you're incorporating the same demon horns, you can express individual differences by varying their number and position, thus expanding the design possibilities.

Size of parts

Making them larger in proportion to the body can emphasize that feature or create a focal point. Making a part larger can also convey power or strength. On the contrary, making them smaller can make them appear cute.

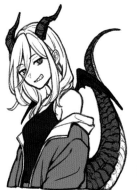

For example, on the left, making the tail larger conveys strength, while on the right, enlarging the wings emphasizes flying ability.

 # Distinctive Bodies

You can always add distinctive parts to a human shape, but sometimes an altogether different species or creature is needed. The impression can vary depending on how much you utilize these distinctive features and whether they're applied to portions of the body or the whole frame.

Examples of Special Settings

Ghosts & monsters

Some might lack feet or be entirely disembodied or have orbs of fire floating around them. Other monsters have a single eye, while zombies and jiangshi are comprised of oozing, rotting flesh.

Furries & anthros

In addition to adding a tail to a human form, you could also design the face to resemble an animal, cover the body with fur or incorporate beastly features. Consider also mermaids, with a human upper body and a fish lower body, or centaurs, with a human upper body and a horse lower body.

Robots & cyborgs

Bipedal humanoid robots. Dressing them can suggest an attempt to blend in with humans. If the setting is a robot modeled after a human, its shape might resemble a human but with mechanical eyes or an emotionless expression to convey that it's not human.

Clothing

The kind of clothing characters wear can greatly influence their overall impression. Begin by deciding the direction you want to take, and then refine the design.

≣ Taste and Style

Typically, you design an outfit or look based on a character's intended identity and appearance. But you can also develop a character around a distinctive ensemble or design. When designing clothing, first decide on the style and inspirations you want to integrate. Using the shape of a basic dress, follow the examples to see how a basic garment can be endlessly transformed.

Cute, Childish
Designs that are generally rounded, such as the neckline, puff sleeves and round-toed shoes. To emphasize cuteness, lace is added to the hem.

Mature, Cool
Designs that show some skin, like exposed shoulders or slit skirts that reveal the legs. To ensure a stylish appearance, the overall silhouette is streamlined, and high heels are added.

Artistic, Unique
Using see-through or shiny materials to create a design that represents a Christmas tree. This design is imagined for special occasions like holiday events or performances.

≡ Design Specifics

Once you've settled on the style and look, you can then specify the design. Changing elements like sleeve and collar shapes, skirt length and the decorative features included can create variations in impression within the same basic design.

Cute, Childish, Sweet, Glamorous **Subdued, Mature, Simple**

A short dress, white tights and platform pumps create a youthful impression. Decorations like frills and large ribbons convey cute and sweet connotations.

A knee-length dress, thin black tights and slender-strapped pumps result in a more subdued design than the one on the left, but puff sleeves and ribbons add a bit of fashion flair.

A straight-lined, square-necked long dress with black tights and pointed pumps give a subdued impression. The simplicity and lack of frills lend focus to the face.

Even with the same cute dress, differences in design can change the impression, right?

How much skin does your character expose? For a more audacious or casual character, low-cut or skimpier attire can work well. Covering your character entirely adds mystery and a sense of concealment. It's up to you!

Creating an Impression

More exposure

Revealing clothing can be one sign of a free-spirited character. When paired with long skirts and other covering garments, the focus on appearance can be downplayed for a more mature look.

Less exposure

Clothes that cover the whole body (such as long coats, robes and knee-length boots) are a good fit for shy, mysterious or secretive characters. A darker palette can be used to create a stronger overall impression.

 A Bit of Advice

Designing against type

Your character will be portrayed in a range of outfits and dressed to reflect a variety of scenes and settings. Take advantage of this freedom. Play against type. A character always seen wearing the same skimpy outfit will become predictable when seen over and again in the same signature outfit. Even adding slight variations, like a wrap or a jacket, adds news dimensions and details.

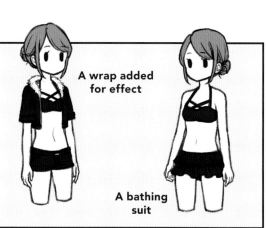

A wrap added for effect

A bathing suit

 Texture and Size of Clothing

Fabrics of course come in a variety of textures and thicknesses. Considering the impression each gives can elevate the quality of an illustration. Also be aware of size and fit when drawing. For instance, dressing characters in oversized clothes can emphasize their small stature or give off a relaxed vibe.

Textural Impressions

Soft and matte clothes

Cotton skirts, linen shirts
Simple, ordinary, sincere, calm, gentle, natural.

Thick and stiff clothes

Denim dresses, knitted cardigans
Casual, moody, plain, boisterous, generous.

Clothes with a glossy finish

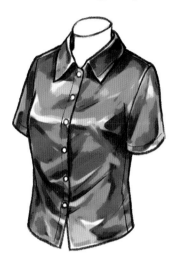

Leather jackets, satin dresses
Strong, cool, luxurious, charismatic, beautiful, sacred.

Size-Related Impressions

Fitted size
Ordinary, serious, sincere, plain, refreshing, clean, intellectual.

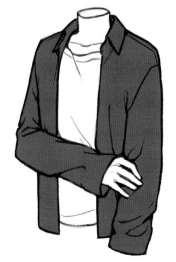

Oversized
Cute, childish, shy, moody, relaxed, unhurried, laid back.

Accessories

Once the design of the clothing is decided, think about the accessories that will be included to finish off the look. Choosing appropriate items for the situation strengthens the visual impact and gives your character context.

≡ Effect of Accessories

Accessories can convey the season or the setting to the viewer. Clearly, just by having a character wear a scarf, one can tell at a glance that it's autumn or winter. And based on its design, a character's individual taste and personality can be expressed.

Examples of Situations and Accessories

On the way home from a convenience store in winter

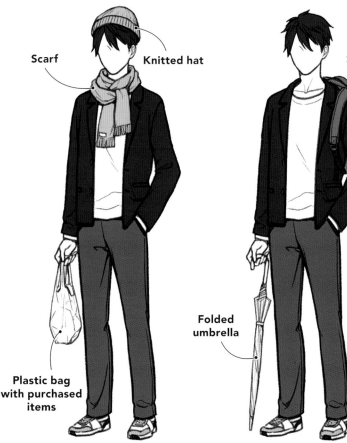

Scarf

Knitted hat

Plastic bag with purchased items

On the way home from university after the rain

School bag

Folded umbrella

Waiting for a concert to start

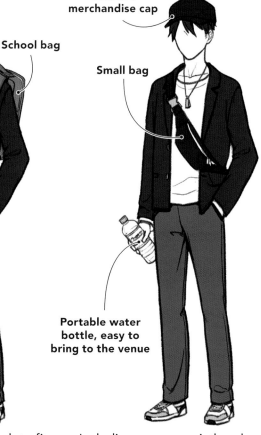

Concert merchandise cap

Small bag

Portable water bottle, easy to bring to the venue

By wearing cold-weather items, the season is suggested. Just by holding a plastic bag helps set the scene.

The bag is large enough to fit notebooks and other items. You might also give him a collapsible umbrella.

Including caps or wristbands, everyday items, is a good idea. The bag should be compact so as not to be too cumbersome.

☰ Design of Accessories

If a character wears glasses, depending on the design, it can make them look intellectual or gentle, aloof or eccentric. Consider a design that fits the character you want to create.

Glasses and the Impressions They Give

Half-rim
With a frame on the upper half of the lens, it gives an intellectual, calm or potentially neurotic impression.

Round
An almost circular design, it suggests a gentle, calm or optimistic impression.

Traditional
Narrowed slightly toward the bottom and rounded in shape, they make a friendly, warm impression.

Square
With a wide horizontal frame, it creates a serious, honest or strict impression.

Hat Styles and the Impressions They Give

Beret
Originally worn by artists, it generally gives off a retro, hip, artistic or boho impression.

Boater
A straw hat with a flat crown. Due to its material and shape, it gives off an old-fashioned charm.

Cap
Sporty and simple, it suggests a boyish, casual, energetic and active impression.

Fedora
An iconic item in crime stories, it gives off a chic, cool or mature impression.

Uniforms & Occupational Outfits

Even without background details or dialogue, having your characters wear symbolic or iconic clothing and uniforms can convey essential information about their role in the story.

🈁 Uniforms & Professions

Unlike manga or anime that depicts a story through dialogue and multiple scenes, illustrations need to convey essential information in just one frame. As in the examples below, by using uniforms or symbolic clothing, you can directly relay the character's profession.

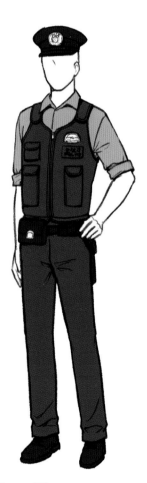 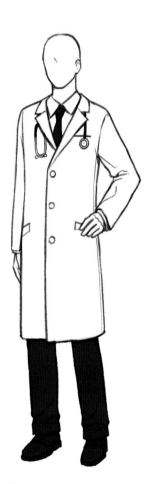 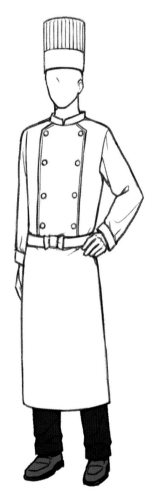

Police officer

A service cap, vest and a belt help signal a police officer. The design of the badge, cap or overall uniform can be distinctive as long as iconic items appear.

Doctor

A long white coat and symbolic items like a stethoscope or a prescription pad instantly signal this profession.

Chef

Wearing a chef's jacket, apron and hat are key. Adding a necktie or a casual hat offers possible variations.

⬛ Fantasy Fashion

Even in a fantasy setting, there are symbolic garments and items that immediately suggest a character's identity or background. Here are three of the most iconic.

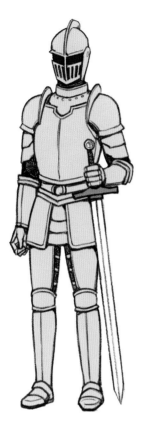 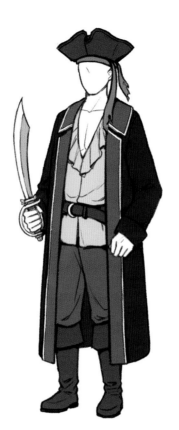 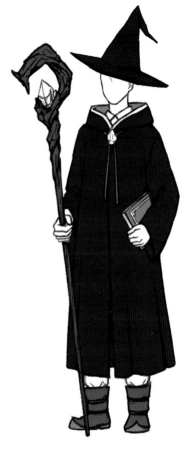

Knight
Wears heavy armor, along with carrying a sword and shield.

Pirate
Has a distinctively designed hat and jacket and carries weapons like swords.

Wizard
Wears a long, pointed hat and robe, often pictured with a staff or a book.

 A Bit of Advice

Customizing the design
Based on clothes that reveal the profession, adjust the design according to the storyline, setting or situation. Especially in a fantasy world, there's more freedom to customize compared to reality-based designs.

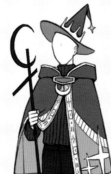

Wizard
A design that imagines cuteness and delicacy by adding star and moon motifs.

Knight
A design emphasizing stealth and ease of movement.

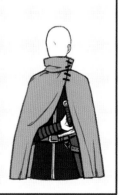

The Information Clothes and Accessories Convey

It's crucial to convey not just the inner characteristics and personalities of your characters through their clothing and accessories but also the kinds of worlds they occupy.

☰ Expressing the World and Era

The setting, era or period of your story can be easily be suggested through characters' clothing. By incorporating clothing and hairstyles symbolizing a specific era or region, you can help set the scene or illustrate settings from historically accurate periods.

Designs Representing Setting

① Reality-based

Clothes and hairstyles as seen in real life, implying a world nearly identical to ours.

② Fantasy-based

Outfits and hairstyles not commonly seen in the everyday. Here is a fantasy ensemble as seen in a China-inspired otherworld.

Designs Representing an Era

① Yayoi period (300 BCE–300 CE)

Wearing a hemp-made garment, with hairstyles based on clay figures from the period.

② Edo period (1603–1867)

Donning a kosode with a black collar, a trend from the latter Edo period, and a Shimada-style hairstyle.

Expressing Environment and Emotional State

The environment where the character exists (whether it's an extremely cold region, a desert with fierce sandstorms, outer space or a war-torn region) can be conveyed through clothing. The same design can also allow the viewer to imagine the character's emotional register or mental state.

Clothing Representing the Environment

Severe cold regions

Wearing a thick coat and hat made of fur, designed to cover the body entirely.

Outer space

Wearing a spacesuit equipped with an oxygen tank and temperature regulation, her hair is tied up to prevent it from getting in the way in zero gravity.

Clothing Reflecting an Emotional State

Financial or emotional strain

Disheveled hair, a tattered shirt with loose threads or missing buttons and socks with holes suggest a frazzled state.

Battle fatigue

Messy hair, worn-out armor full of dents, a torn cape. Even the weapon she wields looks old and battered.

Volume

Even if the base form or basic design remains the same, changing the overall volume alters a design's visual impression. You can adjust the volume by modifying outfits and hairstyles.

☰ Effects of Volume

Increasing the volume of clothing and providing an overall sense of volume to the figure makes the silhouette more prominent. This not only changes the character's impression but can also be used when you want to enhance the character's presence or adjust the white space around the character.

Overall Volume and the Impression Given

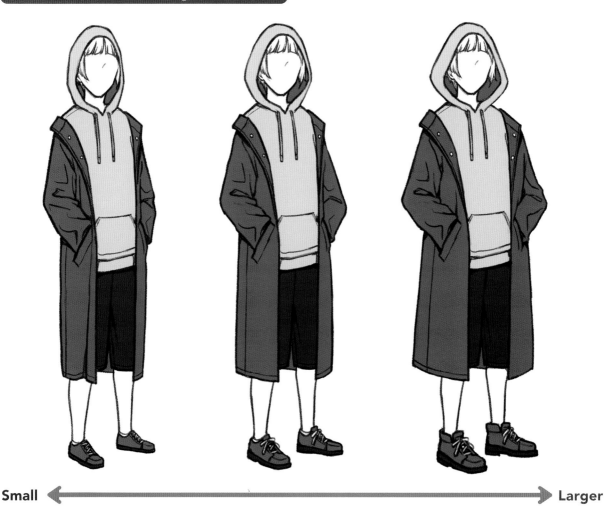

Small ⟵————————————————⟶ **Larger**

Delicate, simple, ordinary, fragile, subdued, cool, shy, intellectual, stiff, etc.

Vibrant, lively, strong, robust, bright, energetic, passionate, soft, etc.

Volume Differences by Parts

 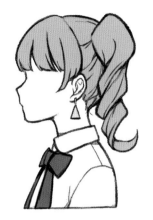

Small ⟵⟶ **Larger**

Adjust the volume using hair, earrings, ribbons, or the collars and sleeves of blouses. When it's challenging to change the overall volume, adjusting specific parts can help. As with the overall figure, increasing the volume of individual elements generally gives a more vibrant impression.

☰ Adding Volume with Items

If the character has short hair or wears tight-fitting clothes, making it difficult to increase the volume, you can add layers or accessories. Consider this approach when the design feels a bit lackluster.

Examples of Adding Items

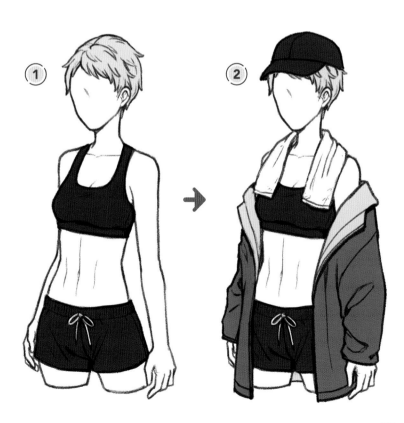

① Original design

The character has a lively and bright personality, but the design is too simple and feels a bit sparse. You'd like the design to be more vibrant but don't want to lose the sporty image.

② Adding accessories

Add hats or towels to increase volume in the upper body. Also, add a jacket that matches the character's image, enlarging the overall silhouette and making the design more vibrant.

Density

When you feel that the design is sparse or lacking, you can add elements such as patterns and designs to increase the density and visual appeal. A higher density can make an illustration look more vibrant and intensify its overall impact.

How to Increase Density

To raise the density, you can add small items or incorporate patterns and decorations into your designs. For characters with a plain or more dressed-down style or for background characters, too much flair or detail might make them stand out in the wrong way, so be prudent. Less is often more.

Impressions Given by Different Densities

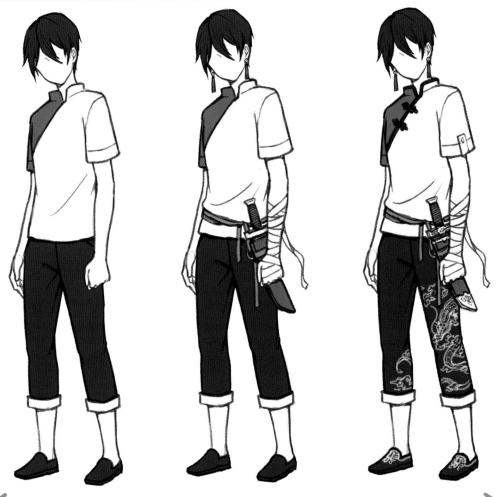

Small ⟵ ⟶ **Larger**

Rustic, ordinary, plain, honest, quiet, serious, calm, gentle, fresh, clean, unremarkable, etc.

Luxurious, flashy, lively, energetic, strong, cool, artistic, stylish, etc.

Ways of Increasing Density

Original design → **Add decorations**

By noting the decorations that catch your attention, you can expand your design repertoire.

Patterns, accessories, lace, ribbons, buttons, lines, pockets and zippers can be added. These can boost the design's density without significantly altering the overall style of the outfit or the character's impression.

Character Image and Density

Depending on the character's personality, profession or other defining qualities, it might be best not to increase the design's density. Always keep the image of the character you want to express at the core when adjusting the design's density.

Examples of Density and Character Impression

① Low density

A doctor who looks serious and kind. The simple design of a white coat over a shirt gives an impression of calmness and cleanliness, simply and effectively signaling he's a doctor.

② High density

A less conventional or nontraditional medical professional. With piercings, a patterned shirt and buttons on the coat, the design is flashy, lacking seriousness and a sense of professionalism.

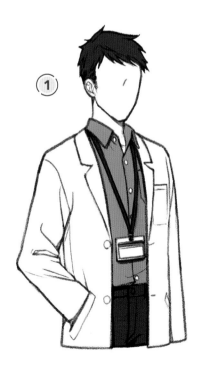

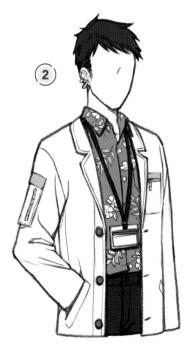

Color Scheme

Colors can have a profound impact on the viewer. You can really make your character stand out by combining colors that capture the mood and attitude you want to express.

☰ Various Color Schemes

As you can see in the examples below, colors have the ability to influence and alter the impression your character makes. When thinking about the main tones and hues of the character's color scheme, it's best to imagine the character first.

Impressions & Associations

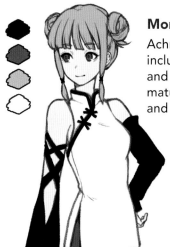

Monotone
Achromatic scheme including black, white and gray. Chic, cool, mature, strong, dark and mysterious.

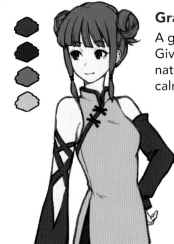

Gray
A grayish palette all over. Gives an impression of natural, calm, sober, calm, stable.

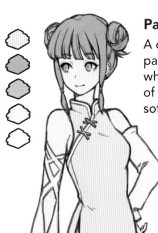

Pastel
A color scheme with a pale color mixed with white. Gives an impression of cute, childish, gentle, soft, delicate.

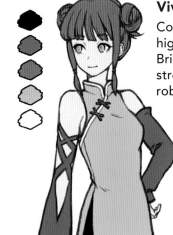

Vivid
Color scheme with highly saturated colors. Bright, energetic, lively, strong, passionate, robust, healthy.

Cold colors

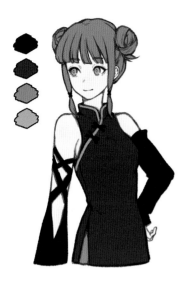

A color scheme can be considered cold or cool when it takes in shades of blue, light blue and blue-green. These palettes give your characters the impression of being calm, intelligent, mature, serious, introverted or altogether transparent.

Warm colors

These include hues and tones of red, orange and yellow. These "hot" colors give a potential impression of being energetic, lively, emotional, extroverted, cheerful, positive and impassioned.

Easy-to-Read Colors

Sometimes, the overall illustration may not be coherent or it isn't readily apparent to the viewer what exactly is going on. If so, make adjustments such as lowering the saturation, altering the brightness or grouping together colors of a similar hue.

Examples of Corrected Color Schemes

Original illustration

A color scheme that incorporates vivid colors with the image of a bright and energetic character. But there is no overall cohesion. There are many colors with high saturation, little difference in lightness and a large number of hues.

Adjusting the brightness

Green and light blue next to each other are close in hue and saturation, so the green became dark green. By creating a difference in the brightness of adjacent colors, the color scheme was sharpened.

Adjusting the hue & saturation

To create a cohesive look, use similar hues, but leave bright, saturated colors such as yellow and orange. The pink has been changed to the same orange as the eyes, and the light blue has been changed to an ocher with a similar but lower-saturation hue used for the yellow of the hair.

Highlights

In illustrations, it's important to emphasize particular aspects you want the viewer to focus on, highlighting or spotlighting these key areas. It's the details that give your characters distinction and set them apart.

Adding Emphasis

By embellishing a design to increase its density or enlarging an item, you can distinguish it from its surroundings and emphasize what you want to showcase. If your character's a music lover or a jock, the revised design on the right certainly sends that message more effectively.

Original design

Embellished design

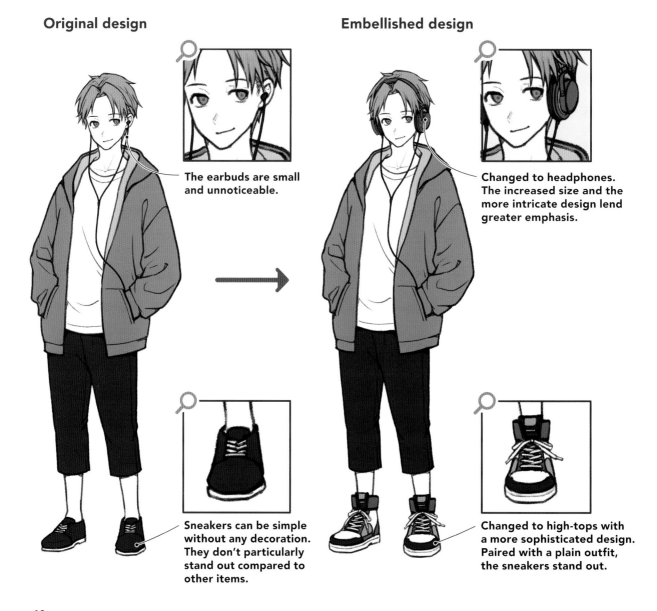

The earbuds are small and unnoticeable.

Changed to headphones. The increased size and the more intricate design lend greater emphasis.

Sneakers can be simple without any decoration. They don't particularly stand out compared to other items.

Changed to high-tops with a more sophisticated design. Paired with a plain outfit, the sneakers stand out.

Emphasis Through Color

Using a color that contrasts with its surroundings can highlight the desired part. Choose a color with a different hue or brightness or opt for a more saturated color than its surroundings. In the example below, complementary colors are used to emphasize the eyes. Complementary colors are opposite each other on the color wheel, such as red and green or yellow and blue.

Original design
The overall design is unified in a reddish hue. While cohesive, there's no distinctive focus.

Emphasized design
The eyes are changed to a teal, which is the complementary color to the red hue, the contrast adding the desired emphasis.

Emphasis by Subtraction

If the overall design has high density or if other areas of the illustration use colors similar to what you want to emphasize, the main focus may not be readily apparent. In such cases, you can de-emphasize the surrounding design to add focus to the part or area you want to stand out.

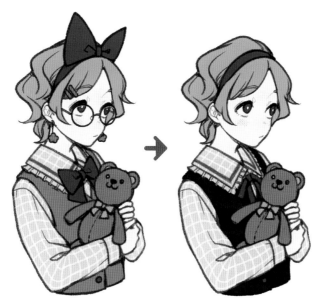

Original design
The design has high density with large ribbons, accessories and glasses. It's flashy, but it's unclear what should be the focal point.

Emphasized design
To highlight the teddy bear, other elements were removed. The ribbon next to the bear is simplified. The vest, which was in the same color family as the stuffed animal, is made a different hue.

Going Beneath the Surface

One way of adding complexity, sophistication and unexpected layering to your characters is to create what can be called a gap or a violation of expectation. This exploits the assumptions at play in the adage, appearances can be deceiving.

Subverting or violating expectation is one way of getting and sustaining your viewer's attention. A mismatched or unexpected disjunction between your character's outward appearance and inner makeup creates a compelling tension that commands attention.

A Couple of Examples

Character design

He gives the impression of being strong and formidable due to the muscular body and scars on his face.

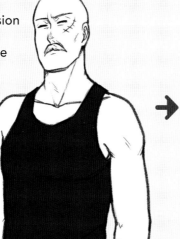

The twist

By showing him petting a cat, an unexpected tenderness and a soothing presence are revealed.

Character design

The straight black hair, designer glasses and clothing choice give off an air of sly seriousness.

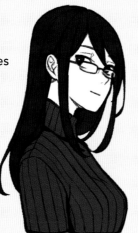

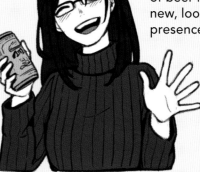

The twist

Laughing, with a can of beer in her hand, a new, looser sociable presence emerges.

Expression & Composition

Once your character designs are complete, consider how best to animate and stage them. Now let's explore the creative possibilities with poses that bring your characters to life, lively expressions and compositional techniques that advance your story and announce your themes.

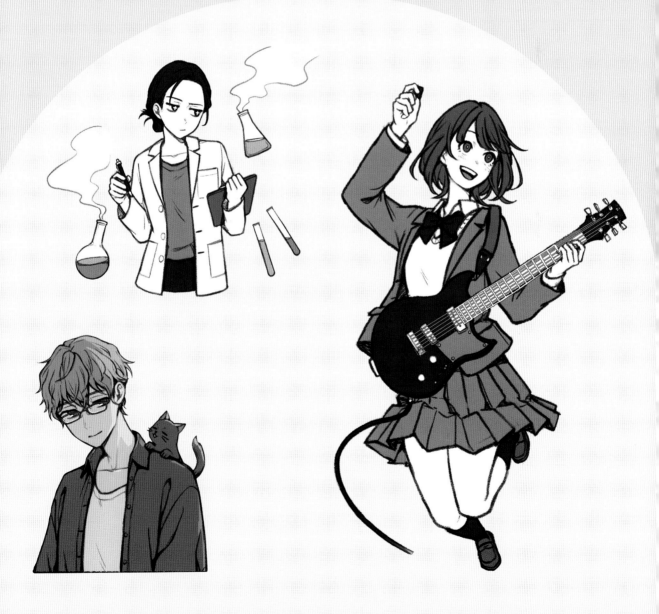

Poses

The first step in bringing your characters to life is giving them a pose, stance or gesture that instantly and clearly telegraphs to your audience exactly what they're doing.

☰ Character-Specific Poses

Even if you have a captivating design, if your characters stand stiffly, their actions or feelings won't be conveyed, and the illustration won't feel alive. Initially, try to apply a pose consistent with the character's image to convey what exactly they're doing.

Two Types of Poses

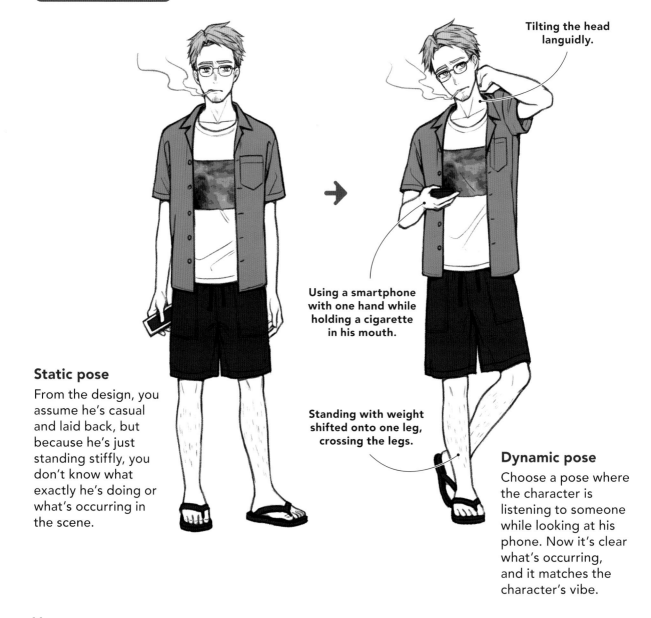

Tilting the head languidly.

Using a smartphone with one hand while holding a cigarette in his mouth.

Standing with weight shifted onto one leg, crossing the legs.

Static pose

From the design, you assume he's casual and laid back, but because he's just standing stiffly, you don't know what exactly he's doing or what's occurring in the scene.

Dynamic pose

Choose a pose where the character is listening to someone while looking at his phone. Now it's clear what's occurring, and it matches the character's vibe.

☰ Poses That Convey Settings and Emotion

Think of a pose with the desired setting or situation in mind. If you want to show a young woman who loves snacking and relaxing, it's more persuasive and clear to show her actually eating and lying down. By enlarging poses, you can also add emphasis and more effectively convey the character's emotions.

Poses That Convey Mood & Setting

Seated pose

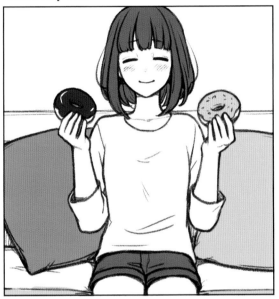

The character is sitting on a sofa with a cushion and holding a snack. It's hard to figure out what exactly she's doing.

Pose that captures the setting

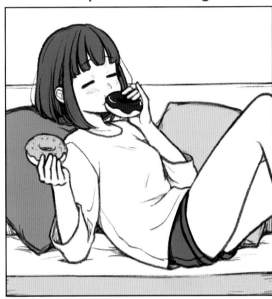

She's lounging, using the cushion as a pillow while munching on donuts. The relaxed and carefree aura is conveyed.

Poses That More Easily Convey Emotion

Static pose

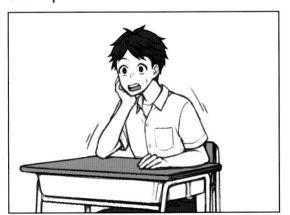

The expression conveys surprise.

Pose that expresses emotion

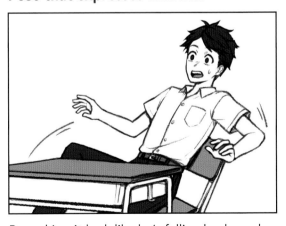

By making it look like he's falling backward, the surprise is vividly expressed.

Gestures

From straightening the spine to a slight downward glance, it's important to master the nuance of gesture and subtle poses, the little things that bring your characters more clearly into focus and lend them life and dynamism.

☰ Character-Specific Gestures

Take the simple act of sitting. There are so many ways of varying that particular pose. By adding gestures like arching the back, placing hands on the knees or tilting the head, you can further signal and pinpoint the character's individuality.

Examples of Character-Specific Gestures

Cool and serious

In a high-ranking security job, she's ready to move, assuming a posture with one knee up, ensuring no unnecessary movements.

Gentle and calm

She loves nature and hiking. Relaxing on the grass, she holds down her hair that's being blown by the wind.

Shy and quiet

On her days off, she often daydreams while looking at her phone on her bed. After returning from school, she sits on the floor of her bedroom, lost in thought.

Confident and optimistic

She runs her own bar. Leaning back with her hands supporting her, she sits cross-legged in a relaxed manner, surveying the interior of the establishment.

☰ Gestures That Express Personality

Even if the design and facial expressions are the same, different gestures can summon and convey a range of qualities and personalities. In the examples, the character has just entered a room. Both use conventional standing poses, but gestures are added according to each character's specific personality.

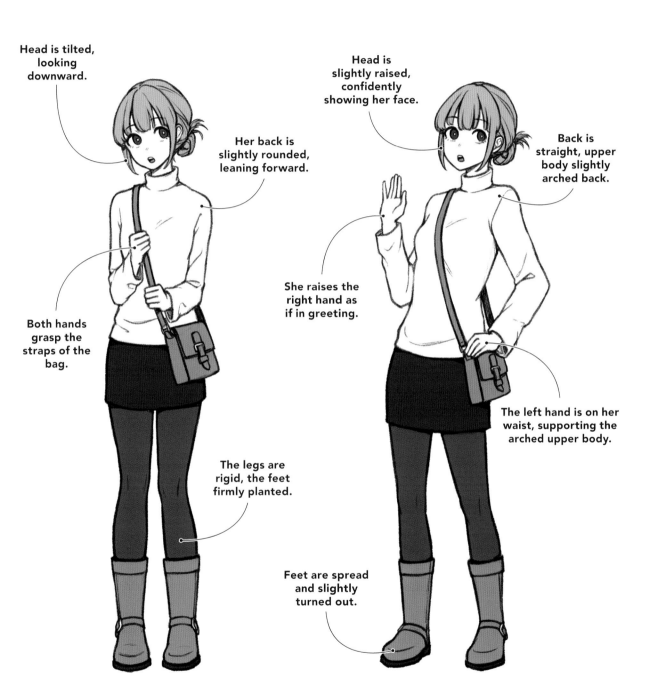

Head is tilted, looking downward.

Her back is slightly rounded, leaning forward.

Both hands grasp the straps of the bag.

The legs are rigid, the feet firmly planted.

Head is slightly raised, confidently showing her face.

Back is straight, upper body slightly arched back.

She raises the right hand as if in greeting.

The left hand is on her waist, supporting the arched upper body.

Feet are spread and slightly turned out.

Shy and reserved
Due to her shyness, she behaves timidly. She enters a room without making a sound.

Friendly and engaging
She's active and always lively, entering the room with a boisterous "What's up!?"

Facial Expressions

Once the poses and gestures have been decided, it's time to reflect your characters' emotions in their facial expressions. These are the essential finishing touches, bringing your scene into focus and adding those final informative emotional details.

☰ Character-Specific Expressions

We all express emotion differently and to varying degrees. Consider that when developing your characters' expressions and reactions. Expressions convey emotion and intensity while also indicating unique traits and qualities.

Happiness & Joy

Calm & Serious
Smiling while looking at a heartwarming scene.

Energetic & Bright
Having a good time talking with friends.

Shy & Reserved
Feeling embarrassed when receiving public praise.

Sociable & Moody
Unable to hold back laughter at a friend's amusing situation.

Sadness & Grief

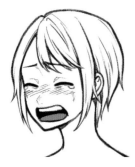

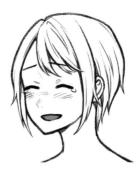

Honest & Emotional
Sobbing because a beloved pet passed away.

Delicate & Introverted
Tired from pondering a painful personal situation and shedding tears.

Strong & Hardworking
Holding back tears of frustration after failing at a club activity.

Gentle & Calm
Mourning the farewell of a dear friend moving far away.

Anger

Serious & Methodical
Slightly angered by something she doesn't agree with.

Emotional & Kind
Sticking up for a friend who's been unfairly treated.

Surprise

Honest & Gentle
Taken aback after getting a small surprise.

Friendly & Adaptable
At a loss for words after hearing some unexpected news.

Other Expressions

Caring & Sensitive
Listening to a sibling's whining and grumbling.

Serious & Neat
Showing contempt for messy, sloppy people.

Delicate & Timid
Fearing an impending reprimand.

Rational & Mischievous
Teasing a very close friend.

A Bit of Advice

Emphasizing expressions with gestures

To express emotions more vividly, you can emphasize them through gestures. With the head tilted back and the hair in motion, you can show intense laughter, while a downward glance and disheveled hair can indicate extreme sadness.

When adding gestures, match and reflect the character's personality.

Items Emphasizing Individuality

When conveying information in a single illustration, it's effective to equip your characters with an item or object that symbolizes their individuality. The right accessory can easily and clearly communicate the character's background and personality.

☰ Choosing the Right Item

Are your characters holding a book, carrying a bow on their back or riding a bicycle? These simple inclusions add depth, detail, layering and complexity. As a result, the viewer can more easily understand the kind of character you're attempting to conjure.

Adding Items and the Impressions They Give

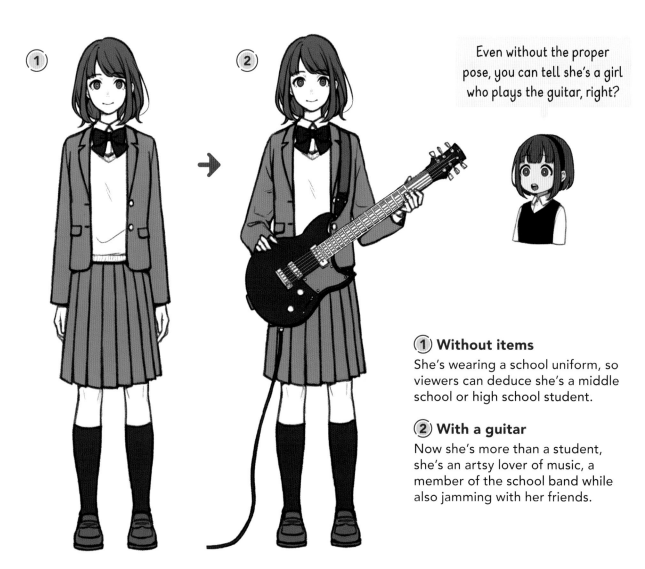

Even without the proper pose, you can tell she's a girl who plays the guitar, right?

① Without items
She's wearing a school uniform, so viewers can deduce she's a middle school or high school student.

② With a guitar
Now she's more than a student, she's an artsy lover of music, a member of the school band while also jamming with her friends.

Poses Tailored to Items & Objects

Certain items have specific ways they are held or used, which can somewhat limit the range of poses. Always imagine the scene, setting or situation in which the character is using the item. Here we'll look at various poses associated with a young aspiring rocker.

Jumping pose

On the day of the live performance, she leaps into the air during the climax of the song.

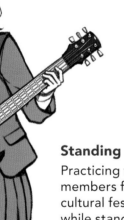

Standing pose

Practicing with band members for the upcoming cultural festival, she plays while standing and moving to the rhythm.

Sitting pose

After returning home from practice, she sits on her bed, cleaning and tuning her guitar.

Wearable Items

How characters wear clothing and accessories can express their inner feelings and defining traits. It can also help create distinctions among multiple, similarly attired characters.

Impression Given by How Items Are Worn

Even with the same shirt design, the impression a character gives can change based on whether the buttons are neatly fastened or several are left undone. In scenarios where multiple characters wear the same style or type of clothing, individuality can be expressed through how they wear it and how they accessorize.

Examples of the Impressions Accessories Create

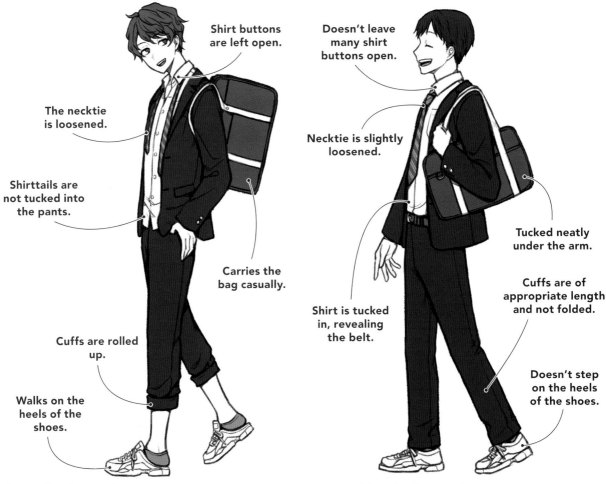

Shirt buttons are left open.

Doesn't leave many shirt buttons open.

The necktie is loosened.

Necktie is slightly loosened.

Shirttails are not tucked into the pants.

Carries the bag casually.

Tucked neatly under the arm.

Shirt is tucked in, revealing the belt.

Cuffs are of appropriate length and not folded.

Cuffs are rolled up.

Walks on the heels of the shoes.

Doesn't step on the heels of the shoes.

Casually dressed

Bright, cheerful, flexible, friendly, flamboyant, frivolous, delinquent, laid back, loose, freewheeling, etc.

Neatly dressed

Perceived as: Ordinary, simple, plain, serious, reserved, honest, calm, kind, clean, unremarkable, etc.

Accessories Adapted to the Setting

How the scarf is wrapped

On the left, it's wrapped neatly, while on the right, the scarf is messy, suiting a child who tried to wrap it herself but failed.

How a uniform is worn

On the left, the uniform is worn properly. On the right, the sleeves are rolled up and the name tag lowered to make room for pens in the pocket. Two different work styles, the casual approach versus the go-getter, are thus summoned.

 A Bit of Advice

Changing the shape of an item

By making adjustments to an item's size or shape, you can greatly alter its impression. Consider these three ways of wearing a jacket: casually draping it for a short outing, wearing it in a stylishly disheveled way or tying the jacket around the waist while working. Each evokes specific impressions and character traits in the viewer.

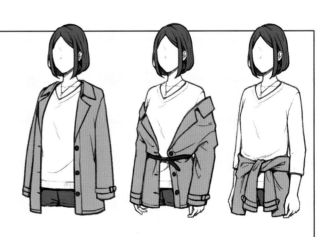

Expressing Dynamism

When a character is in a dynamic pose, such as jumping, try to bring out a sense of movement. The illustration will captivate the viewer.

Ways to Convey Dynamism

When you want to impart movement to a character, start by considering the pose. Make sure that the angles and placement of the character's arms and legs, hands and feet aren't monotonous. Be conscious of the flow of the body's movement.

Examples of How to Convey Dynamism

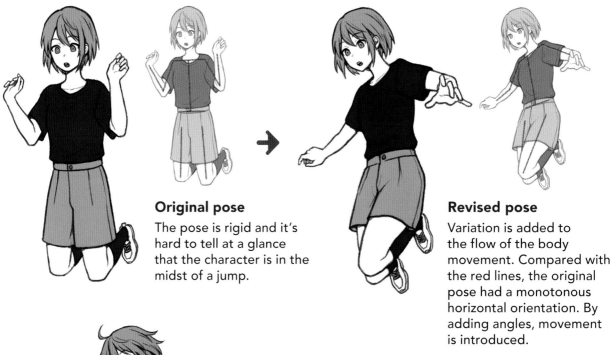

Original pose

The pose is rigid and it's hard to tell at a glance that the character is in the midst of a jump.

Revised pose

Variation is added to the flow of the body movement. Compared with the red lines, the original pose had a monotonous horizontal orientation. By adding angles, movement is introduced.

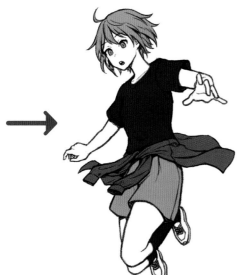

The sense of suspended motion during the jump is more palpable now, isn't it?

Moving hair and clothing

Enhance the sense of movement by making the hair, sleeves and the hem of the pants seem like they're floating upward. To make the pose even more dynamic, add a jacket tied around the waist.

Enhancing Dynamism and Motion

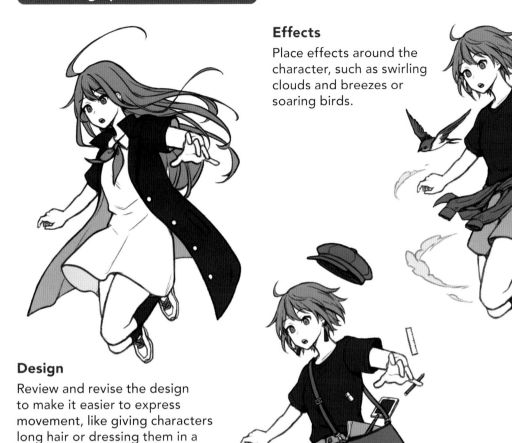

Effects

Place effects around the character, such as swirling clouds and breezes or soaring birds.

Design

Review and revise the design to make it easier to express movement, like giving characters long hair or dressing them in a jacket or flowing robe.

Accessories

Increase the sense of movement with accessories—a hat blown off a head or the contents spilling from a bag.

 A Bit of Advice

When dynamism isn't necessary

If you don't need movement as part of what you want to express, simply don't include it. Intentionally leaving out motion suggests calmness or a settled demeanor. For a scene where a character is seated inside, lost in thought, no movement is necessary. If imagining a character pondering on a windy beach, then add a subtle suggestion of motion.

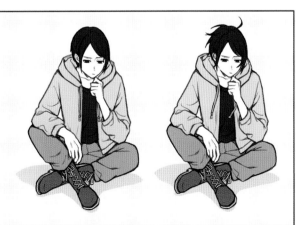

Perspective

One effecting way of adding depth and dynamism to illustrations is through the use of perspective. By making objects that are closer to the viewer larger, you can direct the viewer's gaze, highlighting, pinpointing and emphasizing what you want to express.

Types and Effects of Perspective

Perspective refers to the method of drawing closer objects larger and distant ones smaller. With the use of vanishing-point perspective, objects get smaller as they move or recede toward a point in the background. As your artistry advances, your use, manipulation and command of space improve as well.

Various Vanishing-Point Perspectives

One-point perspective

The simplest form of vanishing-point* perspective. Objects recede toward a single point; effective for expressing depth.

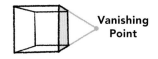

Vanishing Point

As the number of vanishing points increases, the illustration becomes more dynamic by emphasizing the sense of depth.

Two-point perspective

Objects recede toward two vanishing points; mainly used when showing objects from a diagonal angle.

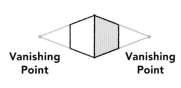

Vanishing Point Vanishing Point

Three-point perspective

An extension of two-point perspective with an added vanishing point. It results in a view from a low or high angle, creating a more dynamic impression.

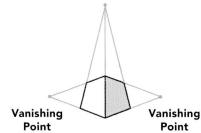

Vanishing Point

Vanishing Point Vanishing Point

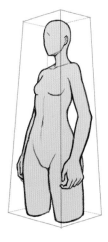

Fish-Eye Perspective

A rounded perspective that resembles the distortion of a fish-eye lens, it creates a sense of depth not just horizontally but also vertically.

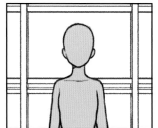

* Lines that are parallel in reality converge as they recede into the distance, meeting at the vanishing point.

Examples Using Perspective

Emphasizing momentum

Changing from two-point perspective to three-point perspective makes the pizza and the character's hand look larger, emphasizing the force and momentum. To further enhance the impact, an exaggerated perspective technique was used, where the foreground objects are drawn much larger while the background objects are much smaller.

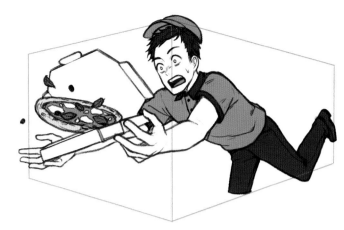

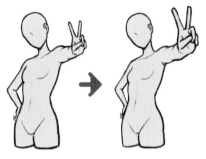

Drawing the hand in the foreground larger emphasizes the sense of depth.

The increased height makes it easier to recognize that the hat is floating.

The pizza and hand appear larger, creating a dynamic impression as if they're flying toward the viewer.

As the body becomes smaller, the objects in the foreground are emphasized relative to the background.

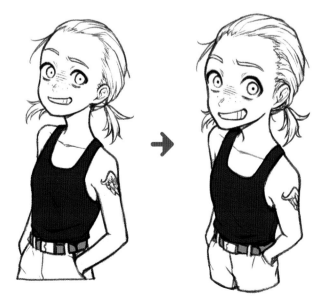

Emphasizing pressure

By incorporating fish-eye perspective, the character's facial expression is emphasized, adding a sense of pressure or fear. Using this perspective makes the entire face appear larger, drawing all the more attention to the expression.

Perspective and Angles

When deciding what part of the character to showcase and what kind of impression you want to create, consider the viewpoint, angles and perspective to ratchet up the visual intensity.

Types and Effects of Viewpoints and Angles

Depending on what you want to illustrate, it's essential to consider the direction and angle from which your composition will be viewed. Let's explore and analyze the characteristics of illustrations from various perspectives.

Frontal

A straightforward viewpoint that easily showcases the character's expression, pose and overall design without any quirks. However, if the character is directly facing the viewer, the composition can seem flat. By slightly tilting the body, extending a weapon forward or widening the stance, a sense of depth is suggested.

If it still feels monotonous, you can make the illustration more appealing by twisting the character's body a bit, letting the clothes flutter, tilting the screen diagonally or adding dynamic effects.

Side

Compared to the frontal view, there's less information about the character. But it's easier to display designs of weapons like bows, guns or large firearms, which might be hard to notice from the front. However, depending on the pose or weapon's size, the character might appear smaller. You can crop the image to focus on the weapon's details. This perspective also complements the placement of multiple characters.

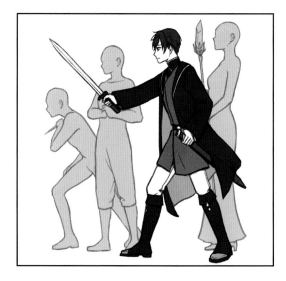

Back

Showcase unique designs on a character's back, show enemy forces represented in the background or highlight what the person is looking at in the illustration. Here, the scene centers on the character advancing toward the enemy's base.

You can also make your characters turn around to reveal their facial expression.

Low or upward angle

In this case, the weapon is emphasized. If characters look directly at the viewer (or into the lens), it gives an impression of them looking down and adds an element of menace or dominance.

High angle (Bird's-eye view)

Here, the character is emphasized rather than the weapon. If the character looks directly at the viewer (or into the camera), he's looking up, suitable for an innocent or supplicating expression.

Light and Shadow

The way a character appears changes depending on the light and shadows created by the light source. With these kinds of nuances and effects, you can create an atmosphere that matches the precise theme you want to express.

☰ Effects of Light and Shadow

When there's a background, you add in and indicate light and shadows according to the environment and scene. You can decide the position of the light source and how the shadow falls based on the mood you want to capture. Drawing shadows increases the visual information present in the illustration, thereby improving and enhancing its quality.

Direction of Light and Its Effects

Frontlighting

Backlighting

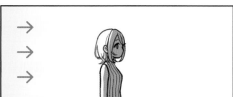

It's the most basic method of illuminating a scene. It easily showcases character designs and their inherent colors*. Shadows tend to be limited, resulting in less visual information and complexity. Depending on the character design, it might appear flat.

* Inherent color refers to the color as perceived under sunlight.

It's used when you want to show off a character's silhouette against brighter surroundings or when you want to give depth to the character's emotions by shading the face. The deeper the shadow, the clearer the silhouette, but the character's inherent color and design become harder to see.

Light from above

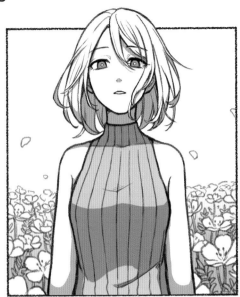

Light typically filters down from above, like sunlight or interior lighting, lending your illustration a familiar, natural shading and look. The shadow of the character falls on the ground, which makes it easier to bring out a sense of three-dimensionality, depth and solidity.

Light from below

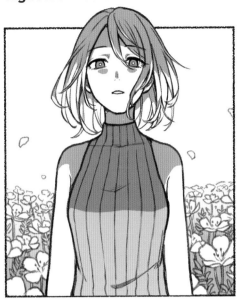

Light coming from below is rare and gives a unique impression. It's suitable for special scenes, like a magical transformation, when you want to suggest intense emotional pressure or when you're aiming for a dark atmosphere.

A Bit of Advice

Intentionally casting shadows

When you feel that a character design is lacking, you can adopt a design that casts more shadow to increase the information. Add shadows by lowering the bangs or adding a hat or umbrella.

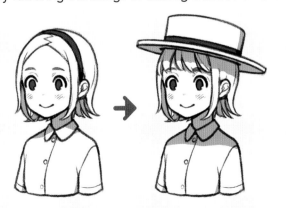

Decide what theme you want to express and add to the design accordingly.

Adding Surrounding Elements

When you want to brighten your illustration, add motifs and effects around the character. Think of something that fits the theme you want to express and let the enhancements refine what you already have.

☰ Environmental Enhancements

Adding elements such as fluttering petals or the effect of weather can infuse a sense of movement and enhance the dynamic environment that surrounds your character.

Movement & Brightness

No added effects

If you want to create a simple impression or express calm and tranquility, you don't need to add any elements to suggest it.

Adding snow or rain

Weather not only adds a sense of dynamism, it can also symbolize or suggest the character's emotions.

Scatter leaves, petals, water droplets

In addition to a lively sense of flow, new colors are introduced, so you can use these elements when you want sharpness and accents.

Butterflies, birds

You can introduce multiple creatures and create a sense of perspective by varying the sizes. Placement is key to creating flow and movement.

Adding Light to the Subject

Brightening the scene

By adding bright light, you can suggest transparency. Borders sharpen and the contrast between elements is heightened, adding a greater sense of visual complexity.

Fog, smoke & mist

By adjusting the density of the haze, you can create a sense of depth. Because it's a fluid motif, it's easy to create a sense of flow and movement.

Motifs & Symbols

Related motifs can always be placed in the background of a single-character illustration. They not only add a sense of movement and visual variety, they provide information and details about your character.

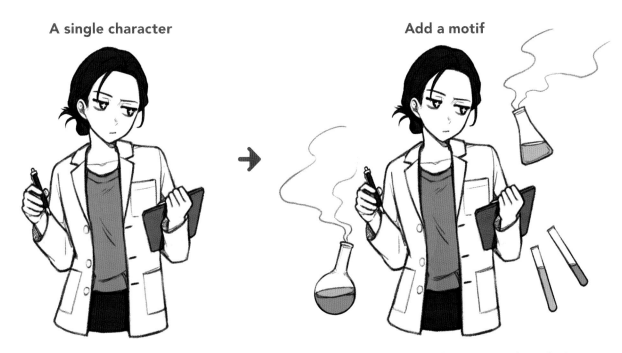

A single character

With the white coat and the clipboard and pen, she looks like a doctor.

Add a motif

With the test tubes and smoking flasks, it's now clear that she's a scientist rather than a doctor.

Composition

Composition refers to how characters or objects are arranged within the illustration. Consider a composition that emphasizes what you want to show, the original creation and protagonist you've worked so hard to create.

☰ Role and Elements of Composition

What do I want to show in the illustration? What kind of information do I want to convey? Ask yourself some key questions, then think of a composition that fits those themes. Even if the composition looks good as an illustration, if it doesn't fit the theme, what you want to express may not be conveyed clearly and effectively.

Key Elements of Composition

Size relative to the screen **Position** **Angle**

By enlarging what you want to show, you can emphasize its importance; by reducing its size, you can show more surrounding information.

Placing something at the edge of the screen can create space around it, giving the screen a sense of expansion.

Deliberately not drawing horizontally but at an angle can convey motion, change or instability.

Relationship with surrounding elements **Perspective and angle**

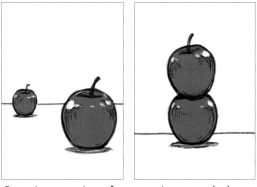
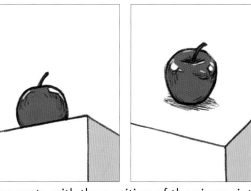

Creating a point of comparison can help in showcasing the protagonist and can provide a narrative.

Innovate with the position of the viewpoint to make the main character stand out. Using low or high angles ensures the composition isn't monotonous.

☰ Composition Tailored to the Theme

Now let's look at a few ways to creatively think about composition. All of them depict a woman sitting on a bench at a train station platform, but the mode of composition varies.

Three Compositional Modes

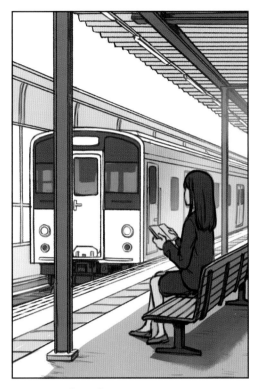

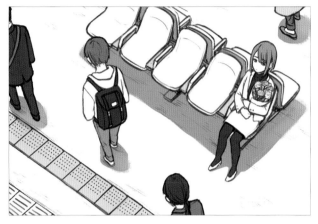

Waiting for someone with a bouquet in hand

Since the character is waiting for someone to arrive, the size of the overall characters is kept small.
To convey the situation clearly, a bird's-eye view is adopted. To introduce motion to the screen, a diagonal orientation is used.

Waiting for the train

The entire illustration shows a station platform with the roofs and pillars visible. The character's entire body is also visible. The character is seen from slightly behind so that the approaching in included. Extraneous elements have been omitted to avoid distraction.

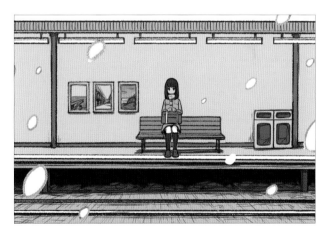

Quietly waiting for the train on a snowy day

To convey a sense of solitude, the character is shown smaller. The viewpoint is straight ahead, and the angle is horizontal. To avoid making it look too flat, a surrounding element, the snow, is drawn in the foreground to create a sense of depth.

Even in the same generic location like a train platform, the composition can vary significantly!

Compositions That Show Facial Expressions

A charming expression as if speaking to someone

To easily see the expression, the character is drawn larger and to enhance the charm, the angle is slightly from above. The character is positioned to the right to leave space to the left rear, opening up the composition. Elements like platform doors and floor tiles are added to indicate it's a train station platform.

Holding back tears

To prevent others from seeing the tears, the character gazes downward. To show the facial expression, the view is angled upward. To symbolically show the character's emotion, the entire frame is tilted to indicate her emotional instability. A station signboard is positioned in the background at the top to indicate the setting.

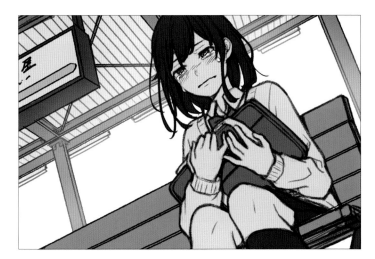

Compositions That Show the Background or Surrounding Elements

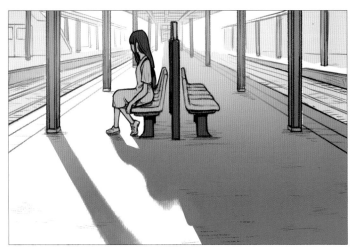

Character silhouette highlighting the beauty of light and shadow

Wanting to emphasize the silhouette more than the detail, the character is drawn small, and a large area is reserved for the area where the shadow falls. The viewpoint is from the side, leading the gaze to the background. To add variation and prevent monotony, the direction of the shadow isn't straight down but tilted to the bottom right.

A young woman gazes at the departure board in wonder

The main subjects are the character and the electronic board. Wanting to show her puzzled expression as she can't understand the train delay information and the text on the display, a diagonal downward-looking angle is adopted. If the viewpoint's too angled, the display becomes too small and the facial expression less visible.

By having the character look up, a relationship between the two main subjects is established.

Compositions That Convey the Relationship with Surrounding Elements

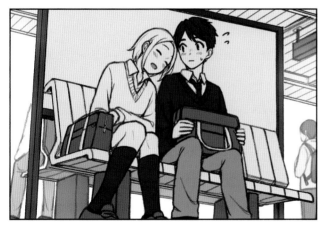

A youthful scene that conveys a budding relationship

To convey the innocent situation, their full bodies are shown. The faces are not too small in order to display their expressions. Instead of a direct frontal view, which can feel static, a slightly upward angle is used for variation. As there's no need to show the background, both people are placed in the center.

Two close friends reuniting

To convey the distance between the two, there is a significant size difference. To show a character is approaching from the distance, the full body is shown in a wide pose. To let the viewer imagine the character came downstairs, the stairs and an escalator are drawn in the background.

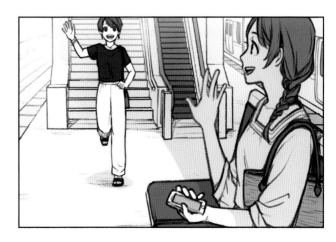

How to Make Your Main Character Stand Out

Even if the composition is strong, if the main character doesn't stand out, it's unclear what you want to showcase. Let's see how we can solve this.

Expression Techniques to Emphasize the Main Character

While you're drawing, sometimes the entire screen can get cluttered, making the main character hard to discern. The right elements or pieces of visual information might not get the viewer's attention. Let's look at ways of creating a contrast between the main character and the surrounding motifs.

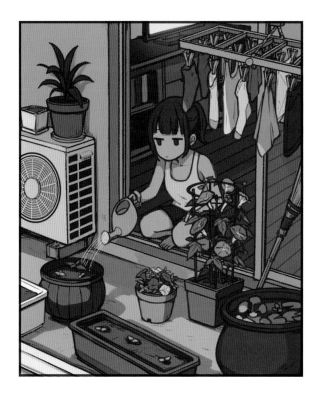

Original Illustration

An illustration of a young woman watering potted plants. Supposed to be the main character, she's hard to see, obscured by the surrounding motifs and background. To emphasize her presence, apart from making the main character larger during composition or reducing the surrounding motifs, adopt one of the following six methods to clarify and focus the imagery.

Six Ways of Emphasizing the Main Character

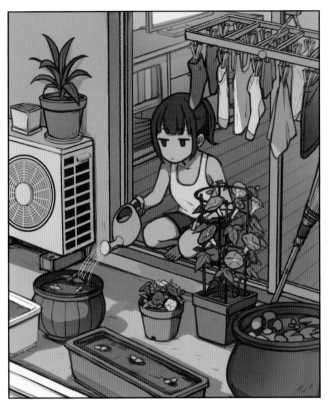

Vary the surrounding colors

By reducing the saturation or increasing the brightness of the surrounding colors, a distinction can be made with the main character. Even if the entire illustration is suffused in pale colors, you can incorporate darker colors into the main character's palette.

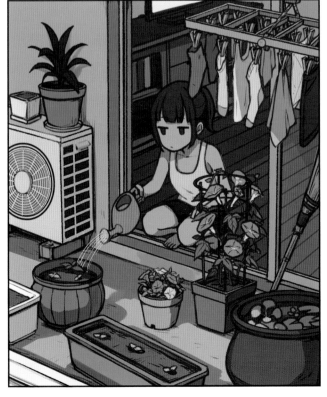

Use different color tones

Differentiate the colors and hues used between the main character and the surroundings. Keep everything in cool tones, but introduce red or orange only to the main character. Alternately, have everything in sepia tones and use only blue or green for the main character.

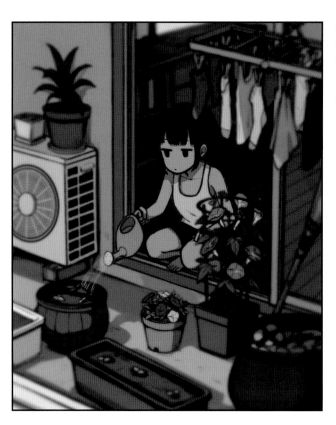

Focus on the main character

Blur the surroundings to draw attention to the main character that's in focus. You can vary the degree of blur between foreground and background or only blur one of them.

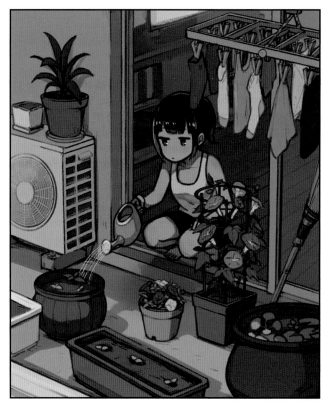

Increase the detailing of the main character

By reducing the details of the surroundings and increasing those of the main character, you can make her stand out. You can always thin out or omit altogether the lines around the main character.

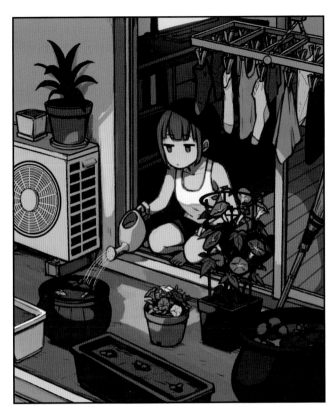

Illuminate the main character

Like a spotlight onstage, shed light on the main character to draw attention. Conversely, you can brighten the entire screen and cast a shadow on the main character to make her stand out.

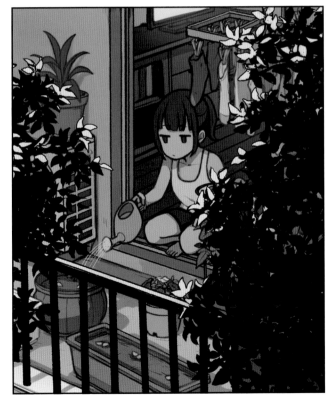

Guide the viewer's gaze with motifs

Add motifs that obscure the surrounding elements to focus the viewer's attention on the main character. If there's a difference in brightness or saturation between the motif and the main character, it makes the depth perception clearer.

Storytelling

Instead of merely depicting motifs, expressing the character's relationship with the surrounding motifs while advancing the narrative can result in a captivating illustration.

☰ Expressing the Relationship

A single illustration has a limited amount of information it can convey. However, with creative expression techniques, you can create an illustration with the depth and resonance of an established narrative. Here, we'll look at ways of telling your story effectively.

Examples of Narrative Methods

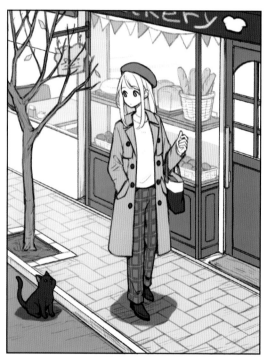

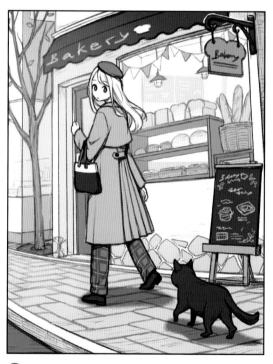

① Depicting only the narrative setting

This illustration portrays an autumn scene where, on a holiday, a woman visits a popular neighborhood bakery. Out of nowhere, a cat approaches. All the motifs described are represented within the frame, so the context is understood. However, since each motif stands alone, in isolation, their relationships aren't immediately clear.

② Revisiting the composition

Ensure that the main characters—the woman and the cat—are prominent. Position the smaller-sized cat in the foreground. Adjust the angle slightly to capture both the woman and the bakery in the frame. This emphasizes the woman and the cat more than the bakery. By adding a bread-shaped sign and placing bread inside the store, the type of business it is becomes even more evident.

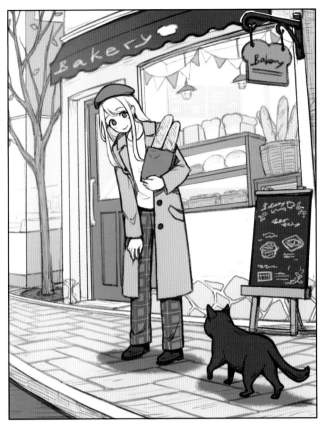

③ Emphasizing the relationship

Change the woman's pose and facial expression. This time, to express her strong interest in the cat, not only is she looking back with an affectionate expression, but she's also slightly bending forward to observe it. Conversely, by having her maintain distance or recoil, you can depict her aversion to cats. By having her hold a freshly bought bread, you also showcase her relationship with the bakery.

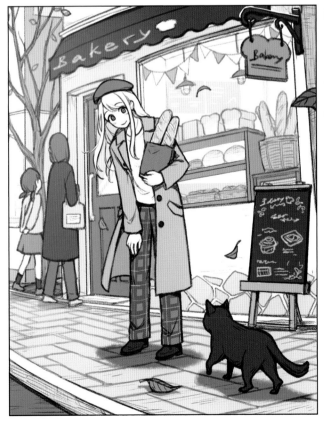

④ Adding surrounding elements

Leverage the autumn setting by scattering fallen leaves around. Create a sense of movement by having the woman's hair and coat flutter. Given the setting of a popular neighborhood bakery, add other customers. Compared to earlier, the woman now has clearer connections to the surrounding motifs.

In some cases, it might be best to focus solely on the most essential information you want to depict.

A Painter's Touch

Depending on what you want to express, changing the brushwork or the method of coloring gives you the versatility you need to refine the palette and bring the illustration into balance.

☰ Brushwork and Coloring Tailored to the Purpose

Although we often draw in a style we find comfortable, get accustomed to differentiating brushwork and coloring based on your desired result.

Examples of Brushwork

Usual brushwork

When there's no particular need to alter the brushwork, express the character in the style you commonly use.

Realistic

When you want to produce a mature and formal ambiance or want to showcase detailed textures. Drawing without omitting shadows can help accentuate depth and three-dimensionality.

Chibi or Caricatured

This style matches well with casual comic or commercial illustrations. You can make even cool characters look adorable using this approach, creating an intriguing contrast.

Examples of Coloring Methods

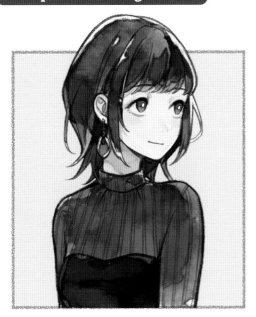

Watercolor

With watercolor's unique spread and color tones, you can create a soft ambiance and a sense of transparency. If you paint everything in a flat, uniform manner, it can be challenging to express depth and texture.

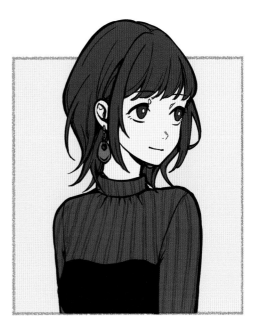

Flat coloring

A method where you color uniformly without gradation or shadows. As the coloration is simple, it emphasizes the beauty of the line art. Since the expression relies solely on lines and color schemes, both need careful consideration.

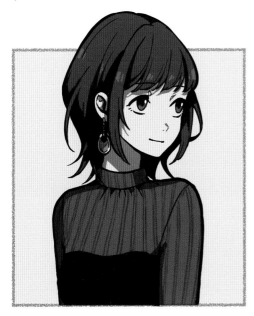

Anime-style coloring

Shading is done with a single, darker hue, making it easier to produce light and shadow effects. With its straightforward coloring, the result is a clean, easy-to-view image.

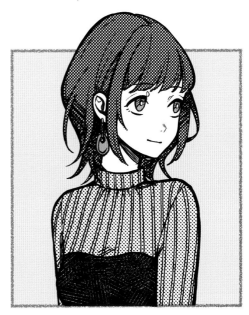

Monochromatic

Ideal when you want to showcase the beauty of pen line art or the balance of solid black coloring. By adding a single spot color, you can also achieve a stylish finish.

Texture

By adding refinements and depicting textures like matte, gloss, scratches and dirt, you can get closer to the true image of the character you want to express.

⬛ Effects of Expressing Texture

By distinguishing the textures of items a character wears or the innate texture of the skin or hair, you add increasing layers of detail and complexity to your illustration. One method is to emphasize what you want to showcase by adding more detailed textures than the surroundings.

Impression Given by Item Textures

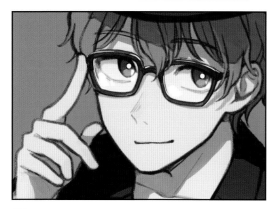

Glossy texture

The frames are given a metallic texture, with reflections added to the lenses. This gives impressions of luxury, coolness or formality.

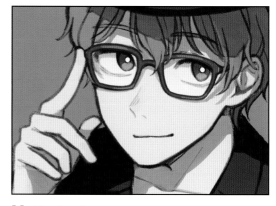

Matte texture

Drawing it like non-glossy plastic gives an impression of something very toy-like, cutesy or pop.

Differentiating Skin Textures

Elderly woman

The skin is wrinkled, and the hair tends to be dry, giving it a matte look.

Young girl

The skin is soft and elastic, and she has thin glossy strands of hair.

Young man

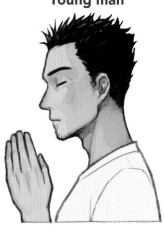

The skin is tough and thick. The hair is stiff, with a glossy feel from the wax applied.

Head-to-Toe Textures

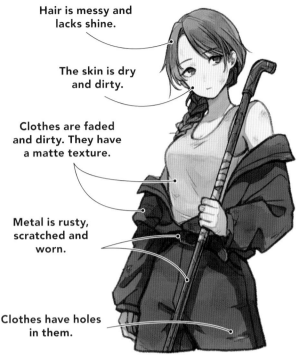

Hair is messy and lacks shine.

The skin is dry and dirty.

Clothes are faded and dirty. They have a matte texture.

Metal is rusty, scratched and worn.

Clothes have holes in them.

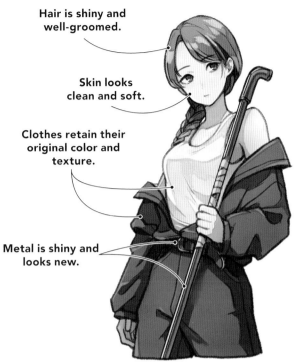

Hair is shiny and well-groomed.

Skin looks clean and soft.

Clothes retain their original color and texture.

Metal is shiny and looks new.

Textures expressing old and worn

Suggests descriptors like weighty, robust, rough, dark, simple, experienced, etc.

Textures expressing clean and new

Suggests associations like clean, serious, refreshing, bright, luxurious, etc.

Adding Emphasis Through Texture

Emphasizing eyes

To draw attention to the protagonist's eyes, highlights were added, and colors were layered to give a clear and beautiful texture.

Emphasizing a piercing

To draw attention to the protagonist's piercing, a glossy texture was added, and delicate colors were layered.

Color Rendering

Consider coloring that reflects the setting, tone and mood of the illustration you're creating and the story you're trying to tell. Fundamentally, you'll adjust hues based on their intrinsic colors.

Types and Purposes of Coloring

By altering brightness, saturation and hue based on the character's intrinsic color, you can effectively enhance your character without distorting the image. When depicting the background and surroundings, you can represent the time of day by choosing appropriate colors.

Themes and Purposes of Color Schemes

Intrinsic

The original color of the character design. When you want to showcase the design's own coloration, you express it in its natural color.

Sepia

Unified in low-saturation warm colors. It can suggest a classic and calm atmosphere.

Pop

Consolidated in bright and vibrant colors. It can express a fresh, energetic feeling or a tropical setting.

Pastel

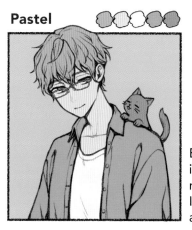

Brighter than the intrinsic color but not too saturated. It can convey a soft and gentle vibe.

Examples of Ambient Light*

Dusk

Depicting a scene bathed in the intense glow of a sunset. The sun almost hits directly from the side, coloring everything in warm hues.

Night

A residential area at night, illuminated by streetlights. Parts of the character are lit up, with an overall bluish purple hue.

Early morning

Capturing the ambiance just before the sun fully rises, with a somewhat misty air. Overall, the colors are soft and bright.

Neon street

A bustling cityscape where various colored lights illuminate the scene. Colors of artificial lights, like pink, aqua and purple, are used.

💡 **A Bit of Advice**

Simple ways to change the color

Create a new layer over the illustration and overlay a single color like a color filter. This can change the entire scheme in one go, creating a cohesive palette. Do you need cool or warm colors? By changing the blending mode and opacity of the layer, different impressions can be achieved. Adjust it according to your desired result.

Overlaying brown with a blending mode [Overlay] at 60% opacity.

Overlaying pink with a blending mode [Soft Light] at 100% opacity.

* Here, it refers to light sources, like the sun or streetlights, that influence the color of the motif.

Points of Entry

Commercial illustrations need to be created according to the client's specifications. Here, we introduce the key points and precautions in meeting and fulfilling your client's needs.

There are various formats for commercial illustrations, such as book cover art and game character illustrations. Depending on the assignment, there may be conditions and constraints. While working within those, creating an attractive illustration is essential. Here, we'll look at some key considerations when it comes to producing book cover art and game illustrations.

Key Points for Book Cover Art

Composition

If you go with the left composition, it's hard to incorporate titles and strips. Therefore, consider the composition on the right. It's also important to consult with the designer about the composition beforehand. Additionally, you need to adjust the drawing density to fit the final size, and consider the composition and motifs.

Colors during printing

If you proceed with using an RGB color image (left), the colors will change significantly when converted to the CMYK format for printing on paper (right). If you want to reproduce the colors as faithfully as possible in print, either draw in CMYK colors from the start or adjust the colors after converting to CMYK.

Key Points for Game Illustrations

Versatility of poses

In game character illustrations, there are instances where different facial expressions are required. Poses like the one on the right, which look odd when facial expressions change, are a no-go. Aim for poses that don't feel out of place even when various facial expressions are applied.

Rarity differences

Since multiple illustrators are often hired, you need to design characters in line with the other characters and storylines. There should be a noticeable difference between low-rarity (left) and high-rarity (right) illustrations.

CHAPTER **3**

Case Studies

Using the character designs in Chapter 1 and the various compositional and expression methods in Chapter 2, let's create some manga! Here we'll introduce how to produce compelling illustrations by looking at a series of case studies.

CASE 01　Draw a Character with Sci-Fi Elements

Concrete Visualization of Your Image

 Choosing a sci-fi theme, how unusual, right?

I've recently fallen in love with the world of a game I've been playing. I wanted to express its stylish coolness! But I don't even know where to begin.

Perhaps you should start by gathering references? Collect illustrations and photos that are close to what you envision and try to find the specific image of the character you want to depict.

IN SUMMARY
Input similar references to clarify your concept.

Collecting Materials

 When gathering materials, jot down any ideas that come to mind, either as drawings or in writing.

Online searches can be a valuable tool.

Idea sketches

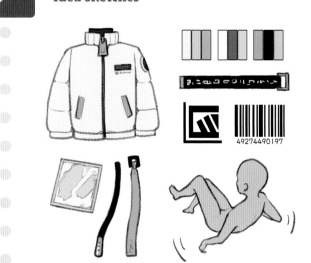

- Combination of monochromatic and neon colors
- Cute logo-like designs
- Designs with a sense of transparency, like vinyl materials, or dangling cords and strings that are interesting
- White clothing looks like a spacesuit and stands out against the pitch-black cosmos
- Even without distinctive hairstyles or body types, we can still bring out the sci-fi feel
- Want to create a floating pose
- Many illustrations have weapons

📃 Thinking of Character Design

 Thanks to what I've seen, I've now got a clearer image in mind!

In that case, it's time for character design. First, set a base for your design, and then add sci-fi elements to it.

Base design **Adding elements**

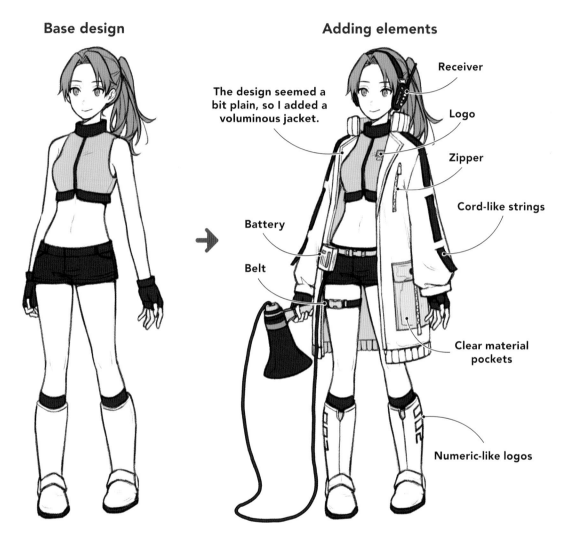

Receiver

The design seemed a bit plain, so I added a voluminous jacket.

Logo

Zipper

Cord-like strings

Battery

Belt

Clear material pockets

Numeric-like logos

I went for a slightly slender and petite body shape. To ensure the overall vibe doesn't get too cute, I combined sporty tops with shorts, bulky mechanical boots and gloves.

 I added the small decorations I liked from my reference collection to the jacket. Lastly, I wanted to give her an item that implies movement, so I gave her a megaphone and cords.

You've managed to design a character that effectively leverages the sci-fi feel you aimed for!

☰ Considering Pose and Composition

 Once the character design is done, let's start bringing the character to life. Do you already have a character setting?

 Yes! The setting is a world (not Earth) where communication is limited. The character has a special ability to broadcast information to various places using the megaphone she carries. I want to convey a feeling of lightness, as if she barely feels gravity, and ensure the megaphone isn't just a mere decoration.

 In that case, envisioning a scene where the character is actually using the megaphone might help you come up with suitable poses and expressions.

Pose Ideas

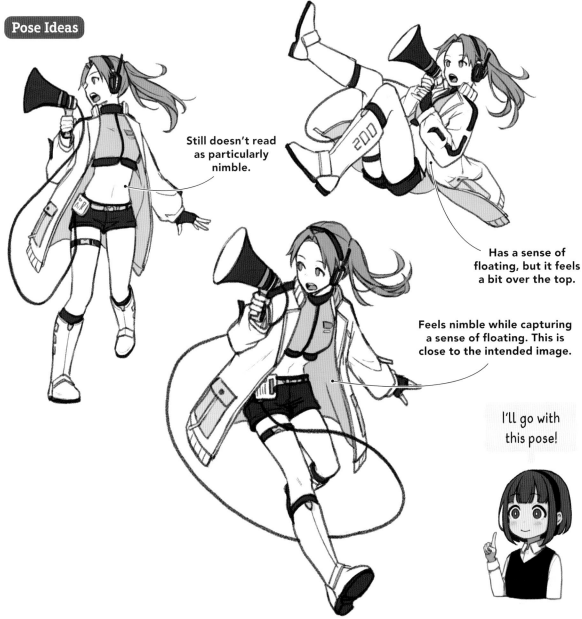

Still doesn't read as particularly nimble.

Has a sense of floating, but it feels a bit over the top.

Feels nimble while capturing a sense of floating. This is close to the intended image.

I'll go with this pose!

Innovate the Method of Expression

Now let's think about the presentation.

Since I want to showcase the character design itself, I plan not to draw a background. For coloring, I intend to express the character's intrinsic colors.

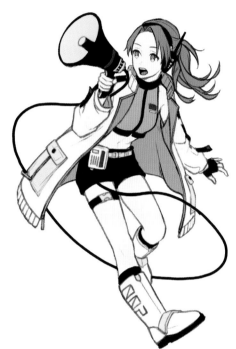

Direct coloring with intrinsic colors

For the spacesuit image, the jacket is white. Unifying the monochromatic palette, I'll add accents with vivid pink and lime green.

Innovative presentation

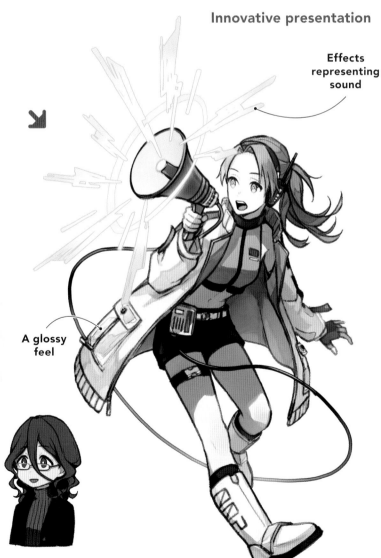

Effects representing sound

A glossy feel

With varied texture rendering and effects, I was able to bring out the sci-fi vibe I envisioned.

By adding effects, you've also created a focal point for the illustration.

 Think About Presentation

 The color of the sky I saw the other day was so beautiful that I incorporated it into my illustration.

I feel like I wasn't able to bring out the stunning colors and environment I wanted to express. I used the same colors as the photo I took.

Illustration based on the colors in the photo

Background sky

Color scheme

clothes and hat **skin** **hair** **background**

 Due to the effect of using sky blue for the entire screen, the colors I want to show are obscured or buried. It seems better to limit the place I use it: either on the character or the background.

Ah, but what color should I choose as a balance and complement?

 It's best to choose colors that make the other hues and tones you want to show stand out. This time, I used colors that are duller than the blue of the sky, the opposite color of blue*, and achromatic colors such as white and black.

IN SUMMARY

Limit or narrow down the places where you use the main color you want to highlight, adding complementary hues to make it stand out.

* Colors that are located on the opposite side of the color wheel (complementary colors), such as bluish purple and blue for yellow or bluish green and green for red.

Coloring His World

Hard-to-see color schemes

 When combined with similar colors, the blue of the sky is obscured.

 When combined with highly saturated colors, the blue of the sky appears dull.

Complementary color schemes

 When combined with less saturated colors, the blue of the sky stands out.

 When combined with the opposite color, the blue of the sky stands out.

Non-interfering achromatic colors

 If you want to show a dark color, combine it with white.

 If you want to show a bright color, combine it with black.

Changing the Color Scheme

Show the color of the sky in the foreground

Limit the color of the sky to only the clothes and hat worn by the character. The background is a dull color with low saturation.

Represent the color of the sky in the background

The color of the sky is reflected in the background. Decrease the brightness of the character so that the background color looks more vivid.

 I've been playing with ways of using the color of the sky.

The color of the sky stands out, and the characters are easier to see!

 Yes, however, the beautiful colors that you wanted to capture at the beginning haven't been fully realized yet, so a bit more refinement is needed.

Creating a Refreshing Feeling

 To bring out a sense of freshness, I brightened the overall color scheme.
I added shadows to the left side and incorporated light on the right side.

Expressing the color of the sky through a character

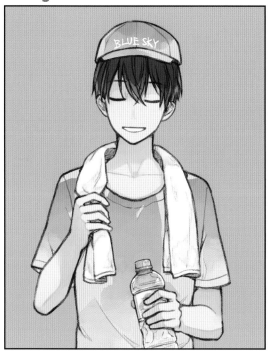

Here, I brightened the overall color and added shadows to the character to prevent it from looking flat.

Expressing the color of the sky in the background

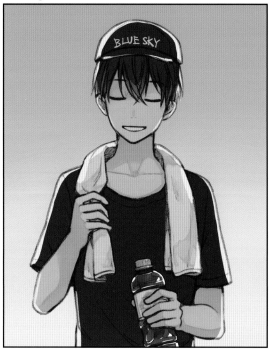

And here I brightened the overall color and added highlights to the clothes and hat to convey a sense of backlighting.

 It feels more refreshing than before! But, why did you decide to brighten the overall color tone?

Darker, dull colors don't easily convey a refreshing feel. So, even for the shadows, I avoided dark shades and chose a bright orange.

Impressions Based on Color Brightness

Low
Dark, heavy, mature, calm

High
Bright, light, refreshing

 Innovating with Strokes

You can convey the desired ambiance with brushstrokes and other techniques.

Draw with watercolor strokes

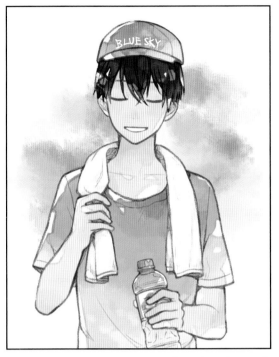

The entire illustration is rendered with a soft watercolor touch. A bleeding effect was used to express the gradient of the sky and the softness of the clouds.

Incorporate the sky motif

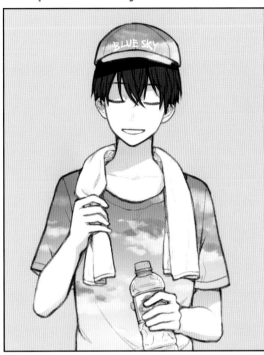

The hat and T-shirt are here treated as a single canvas with the sky and clouds projected onto them. The other colors are subdued, the black and paler shades.

 A Bit of Advice

Emphasizing difference in smaller areas

The color you want can be hard to convey if the area is small (as on the left). It's safer to incorporate it into larger parts. However, even with small areas, you can make it stand out by unifying other parts monochromatically (as on the right), making the color glow, or composing it in a way that draws attention to the color.

Through the illustration, the beautiful colors of the sky and its refreshing vibe come through!

CASE 03 Draw Clothes with a Unique Design

☰ Incorporate Motifs That Express Individuality

 Oh, are you worried about something?

Well, the thing is the clothes I design for my characters, they lack uniqueness, or rather, they look like something I've seen somewhere before. What am I missing?

 What kind of clothes do you usually design? Can you show me?

It's for the protagonist of my next illustration. Even though I reference various materials for the design, it ends up looking outdated or generic.

Design ideas for character clothing

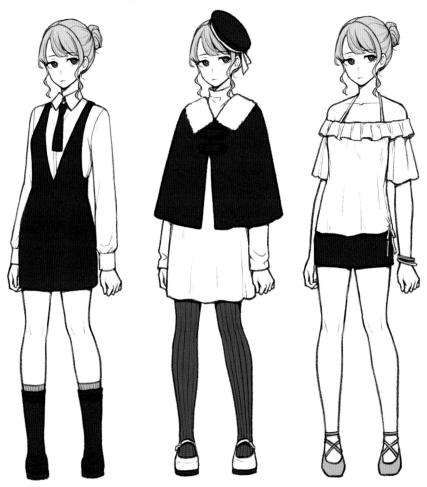

 This design is good as it is, but do you want a more unique design?

Yes, I want to draw clothes that suit a protagonist!

 In that case, you could refer to designs from a completely different field and connect them to new ideas. Anything goes, whether it's objects, scenery or living creatures.
Let's try to find a design you like from motifs unrelated to clothing.

IN SUMMARY
Connect motifs unrelated to clothing to the design.

Search for Designs from Motifs

I've gathered things that caught my eye from recent works
I've seen and from my surroundings.

It's good to take notes on what you find appealing in each motif.

Idea sketches

Shell

The variety of shapes is interesting. While they're actually rigid, their rounded and seemingly soft form is cute.

Insect wings

The delicate patterns in the translucent parts are appealing. I love the vibrant colors and the shape.

Circuitboard

This dense, cluttered look is endlessly fascinating. I like the toy-like feel of it.

Antique-style lamp

I love the retro atmosphere. The combination of different textures, metal and glass, is nice. The light in the bulb is beautiful.

Fish bones

I like the balance between the head and the airy feel of the rest of the bones.

☰ Incorporating Motifs into Clothing Design

Once you've sorted out the motifs and their characteristics, let's think about the clothing design. Drawing a whole outfit at once might be difficult, so let's start by sketching out ideas for individual clothing items.

Fish bones × cloak

A sheer cloak with tassels that resemble the tailfins of the fish.

Shells × boots/tights

The soft-looking shape of the shells, which resembles lace, can be incorporated into boots or tights.

Antique lamp × hat

A hat designed after the lamp's frame, combining metal, glass and fabric—three different materials.

Insect wings × tops

Designing a top inspired by wings that spread out from the center.

Circuit board × dress

Incorporating the detailed look of the circuitboard into the pattern of a dress, which has a linear design.

Once the designs are done, decide which ones to adopt. Incorporating all might disrupt the overall harmony, so limit the number!

Exactly, if everything is combined, the resulting design might seem cluttered and inconsistent rather than showcasing each motif's charm.

Organizing and Emphasizing the Design

Since there's a theme with ocean elements, I've designed an outfit focused on fish bones and shells (on the left). I'm fond of the cloak inspired by fish bones.

Well then, let's refine the design to emphasize the protagonist's charm.

Designs with incorporated motifs
The design overall lacks contrast because we've simply added items.

Organized & emphasized design
Reduce unnecessary designs and emphasize the parts you want to showcase.

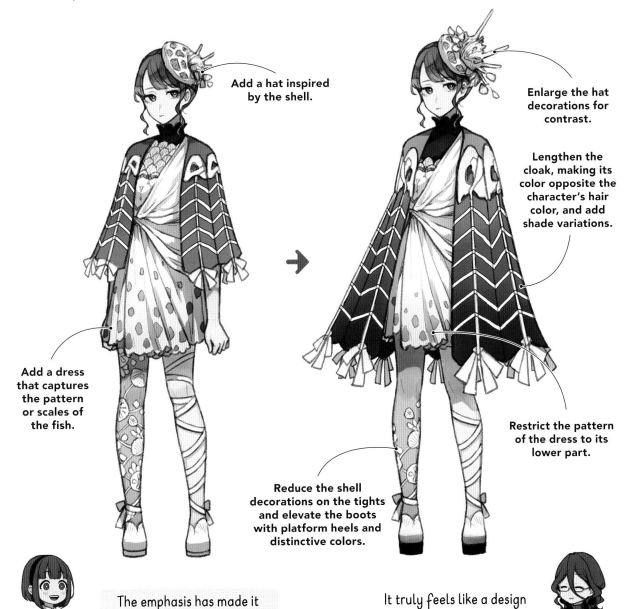

Add a hat inspired by the shell.

Enlarge the hat decorations for contrast.

Lengthen the cloak, making its color opposite the character's hair color, and add shade variations.

Add a dress that captures the pattern or scales of the fish.

Restrict the pattern of the dress to its lower part.

Reduce the shell decorations on the tights and elevate the boots with platform heels and distinctive colors.

The emphasis has made it look much more glamorous!

It truly feels like a design worthy of the protagonist!

CASE 04 Draw Relationships Between Characters

☰ Expressing Relationships Through Similarities and Distance

 The other day, I saw a young boy holding hands with an old lady at the supermarket. I love seeing such heartwarming relationships.

That's how this illustration was born?

Illustration depicting their closeness

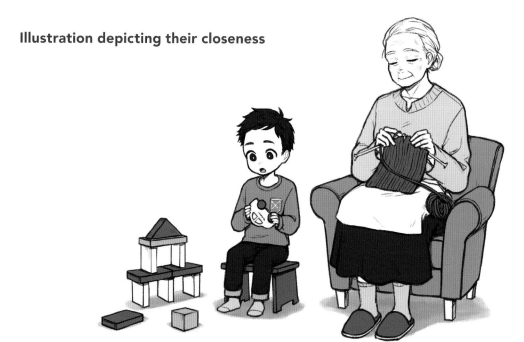

 Yes! However, the affection and warmth I had in mind don't seem to be reflected well in it.

While both characters are in the same frame, they appear independent. To express a close relationship between characters, it's helpful to consider their commonalities and the distance between them.

 Commonalities and distance?

For instance, commonalities could be the characters eating together or wearing clothes with the same pattern. Distance refers to the physical closeness, like sitting near each other or holding hands. Let's try to incorporate these elements.

> **IN SUMMARY**
> Express a close relationship based on commonalities and distance.

≡ Creating Commonalities and Changing Distance

 I tried incorporating commonalities and distance.

Example of creating commonalities

By changing the direction the boy is facing and having him meet the gaze of the grandmother, their closeness is suggested. Furthermore, by having them converse, a commonality is created.

Example of creating commonalities

By giving the boy some yarn, it appears as if he is helping the grandmother, suggesting that they're working together.

Example of incorporating commonalities & distance

Creating a commonality by having them sit on the same sofa. By also reducing the physical distance between them, their closeness is conveyed.

 Is there something that comes close to this image?

The first one, where the two are facing each other with a smile, I thought, 'That's nice!'

 ## Arranging Facial Expressions and Gestures

If you can express the relationship between the two through composition and poses, the next step is facial expressions and gestures. If the facial expressions and gestures tend to be stiff, drawing them a bit exaggeratedly will make the character come to life.

Changing the expression
Softened and transformed into a joyful expression. To convey this to the viewer, I drew it a bit exaggeratedly.

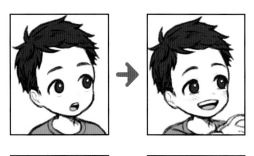

Reflecting facial expressions and gestures
With their warm expressions, the closeness between them is emphasized. The gesture gives the boy a youthful and innocent vibe, contrasting with the grandmother's steady composure.

Changing the gesture
Since the boy was sitting the same way as the grandmother, I changed it to a sitting posture characteristic of the character.

The relationship between an innocent grandson and a kind grandmother has become more evident!

Producing a Narrative

 With some key additions, you can also express a narrative.

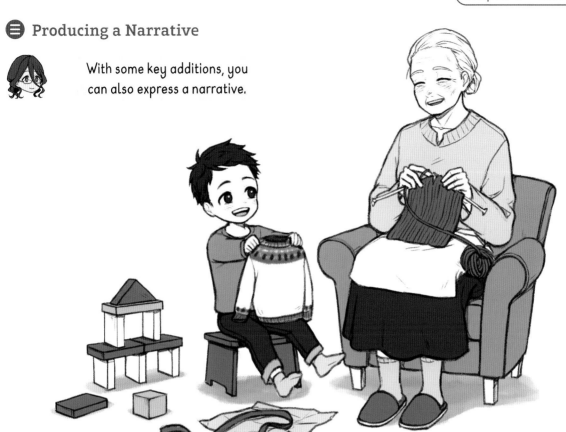

Changing/Adding items
The boy's toy has been changed to a sweater. Placing wrapping paper around suggests he's been given a handmade gift.

The distance between the two has been reduced, and the heartwarming atmosphere I imagined was expressed!

💡 **A Bit of Advice**

Deciding on a situation The relationship between characters is easier to express not only by deciding on a specific situation, setting or world view.

Setting only
The student and the instructor in a standard pose.

Setting + situation
The instructor is teaching while drawing with her student. Incorporating situational details made it easier to convey the mentor-mentee relationship.

CASE 05 — Draw an Illustration of an Existing Character

☰ Considering What to Emphasize

Is this Kurotan, the character from the Japanese app game?

Yes, it is. I'm drawing a celebratory illustration for the first anniversary.

For such illustrations, you try to match the official art style, right?

Sometimes, but there's no such specification this time. Here's the request.

Request for Commemorative Illustration

Official image of Kurotan

OVERVIEW

First anniversary commemorative illustration for a popular app game. Commissioned for posting on the official website and social media sites.

POINTS TO NOTE DURING PRODUCTION

- Vertical layout with a size of 2894px in height and 2046px in width.
- The game's logo will be added to the corner of the illustration later.
- Include phrases like "Happy First Anniversary" or "Congratulations."

ABOUT THE CHARACTER

Kurotan is reserved and has a cool demeanor. He may come off as aloof, but he's also quite caring. He loves hamburgers.

May I watch you work?

Sure, I got the O.K. from the person in charge.

 Since there's no style specified this time, I can draw freely. However, I need to capture the character's essence, or it might look like a different character.

It seems challenging, especially if the character doesn't have distinct features.

 Kurotan has distinctive design elements and items he holds. But if I incorporate aspects of my own style while matching the proportions of the official design, it will look more like Kurotan.

Official style

Caricature-like with flat tones and pop art colors. The colored lines have varying thicknesses and are distinctive.

Instructor's style

The proportions are taller, and the touch is different. One can recognize it's Kurotan from his distinctive clothes and items, but this version could suggest another character altogether.

Matching the proportions

I won't adopt the pop look of the official image, but by adjusting the proportions, it becomes more like Kurotan.

Matching the touch

Keeping the usual proportions from my illustrations, I adjusted the touch, yielding a more complete, detailed character.

With the shared elements, the two versions both look distinctively like Kurotan!

IN SUMMARY

Create commonalities through the style you adopt.

 ## Thinking of a Composition Suited for a Designated Purpose

 I'll be considering the composition with three points in mind: the designated layout, space for including logos and posting on official websites.

Considering the vertical layout

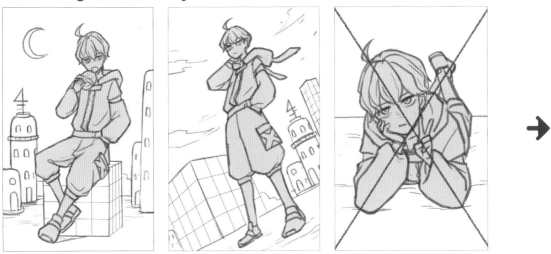

I need to think of a composition where the protagonist, Kurotan, is prominently displayed. Even if it's a good composition, a pose that doesn't suit the character (as shown on the right) isn't feasible. Since I want to give him the iconic hamburger, I'll consider the composition shown on the left.

Considering placement of logos and text

I need to incorporate the specified game logo and the congratulatory text. If Kurotan is too small and there's no dynamic movement, the overall effect can become monotonous.

Being aware of web posting

Assuming many will view the illustration on smartphones via official websites or social media, I re-evaluated the composition to ensure it would still be eye-catching even when displayed as a small thumbnail.

 In the end, I settled on the composition shown in the middle of the bottom row.

☰ Reflecting Feedback

 What happened with the previous Kurotan illustration?

After settling on the composition, I created a rough sketch and showed it to the client. They felt that while it matched the cool image of the character, they hoped for a more celebratory vibe, so I incorporated that feedback into the final piece.

 The vibe is different from your usual illustrations!

The initial rough sketch

Final illustration

I leaned toward the official style, aiming for a pop feel with anime-style coloring. Conveying his cool demeanor, I used calm, cool colors for the overall scheme. However, to ensure it didn't become too subdued, I used a bright color for the celebratory text.

To infuse the illustration with a festive brightness and movement, I added vibrant pink and yellow confetti and streamers, revisiting the overall color scheme. I illuminated the character but left shadows on the face to suggest a sense of aloofness.

While the character's impression remains unchanged, the overall vibe has become more lively!

CASE 06 Draw a Character in a Vehicle

≣ Decide on the Mode of Transportation

 What are you focusing on now?

I want to draw a scene where students at a magic academy are going to school. I was thinking, 'Wouldn't it be interesting if they came to school in unusual vehicles?' But I'm not sure what kind of vehicle would be best.

 In that case, let's start by solidifying the setting to think of the vehicle design.

IN SUMMARY

To decide on the vehicle's design, make the setting more concrete.

 Decide how they move. For instance, do they run on the ground, soar in the sky or move underwater? It might be interesting if there's a giant slide or a ropeway installed as the school route.

Student design
Students dressed in the uniform of the magic school.

Examples of modes of movement

On the ground

 In the sky

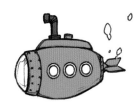 Underwater

Using slides, ziplines or ropeways

Flying seems closest to what I'm picturing!

☰ Decide on the Type of Vehicle

 Next is the type of vehicle. When we say vehicle, there are types where you get inside, types you straddle, and types where you stand on top.

Get-inside type

Trains, boats, airplanes: they're large, so the vehicle becomes the main focus, making the character relatively small. You can always add other passengers or show the interior.

Straddle type

Motorcycles or brooms work well. Both the character and the vehicle can be shown, and their movements easily synchronized. Often there's a seat, ensuring a stable riding position.

Stand-on-top type

Skateboards come to mind. They are often small. The character can hold the item, and there's a high degree of freedom in posing.

Along with the vehicle design, I also want to showcase the design of the student uniforms. So straddling or standing would be best!

☰ Decide on a Design Base

 Let's think about the vehicle design. Given the fantasy setting, you can even use non-vehicle motifs as a base.

Existing vehicles

Like motorcycles or bicycles. It's easy to visualize them being ridden, and there are ample references.

Unusual options

Items like carpets, houses or sofas. They can bring out fantasy elements and originality.

Creatures

Camels, elephants, birds, fish, even mushrooms. They can run on the ground, fly or cross the sea, showcasing the creature's characteristics.

Others

Inorganic objects like planks or clouds. It's possible to design them uniquely so they fit the setting easily.

Since it's fantasy, perhaps the nontraditional options or the creatures would be good choices.

 ## Alter the Design to Make It Look Like a Vehicle

 You can use the base design as is, but by tweaking it, you can emphasize its vehicular qualities. Let's use a mushroom as an example.

Using the motif as is

It doesn't look much like a vehicle.

Design tweaks

Revise it to resemble things like balloons or motorcycles. Choosing a distinctive motif like a mushroom can make the design unique.

Deciding on the size

For fantasy, there's no fixed size for the vehicle, so decide based on the overall effect you want to express.

 ## Small

Play with size and create unusual pairings and proportions. Here a character rides a harnessed bird.

Small ← → **Large**

Can express agility or cuteness.

Balances well with the character.

Can express heft, stability and a powerful presence.

Directing the Riding Position

Thanks to deciding the setting beforehand, I've managed a design that feels just right!

Vehicle settings and final design

Mode of movement Flying

Type Straddled

Base motif Broom

Design tweaks
I've set it in a world where technology has advanced, so I made the broom look mechanical; to add unique elements, I attached a seat and insect-like wings.

Size
A size that a student can carry by herself.

A broom certainly fits the setting of a magical academy. When actually pairing it with a character, let's also get creative with the way of riding and movement expression.

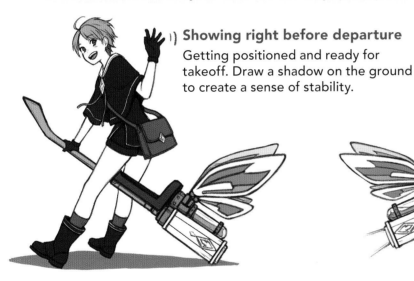

1) **Showing right before departure**
Getting positioned and ready for takeoff. Draw a shadow on the ground to create a sense of stability.

Conveying a floating feeling
Suggest movement by letting the clothes and hair flow gently. The imbalanced, unstable pose lends a relaxed feel and conveys a moderate sense of motion.

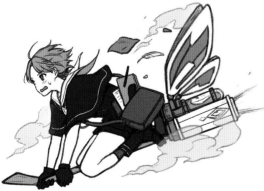

Conveying speed
Express speed with this more intense pose. Emphasize the direction and momentum with wind currents and items spilling out of a bag.

The same vehicle can fit various scenes!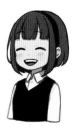

Draw an Adventurous Character

≡ Base the Design on the World View

So now it's time for an explorer and an adventurer? Was there any particular inspiration?

Yes. I suddenly wanted to travel, and while looking at photos from overseas, I found the vibrant scenes and colorful traditional crafts so enchanting. I wanted to draw a character that embodies that foreign atmosphere.

What kind of world does this character belong to?

The setting and character details are as follows!

Idea sketches

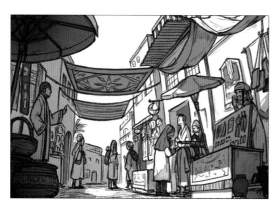

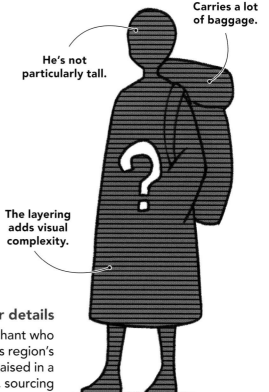

Carries a lot of baggage.

He's not particularly tall.

The layering adds visual complexity.

Setting

A city by an oasis in a desert region, the square always bustling with tourists.
Due to the intense sunlight, parasols and sunshades dominate.

Character details

A man in his late teens, a traveling merchant who has come from a distant land to sell his region's traditional crafts and accessories. Raised in a small town, he now travels the world, sourcing goods and peddling his wares.

 I tried drawing the character based on this backstory and setting. The initial design (left) didn't quite match the image in my head, so I made revisions (right) based on what I learned in Chapter 1.

Initial design **Revised design**

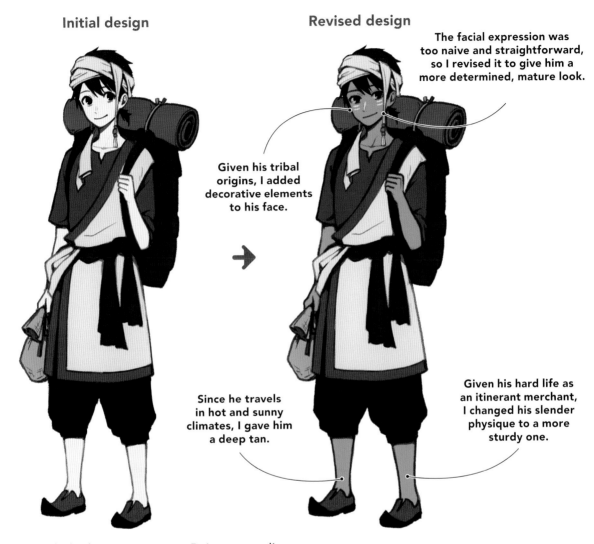

The facial expression was too naive and straightforward, so I revised it to give him a more determined, mature look.

Given his tribal origins, I added decorative elements to his face.

Since he travels in hot and sunny climates, I gave him a deep tan.

Given his hard life as an itinerant merchant, I changed his slender physique to a more sturdy one.

A petite, agile-looking young man. Being a traveling merchant, he carries a lot of baggage on his back. His clothing is casual and loose for ease of motion.

 Hmm, the character's image is closer to what I had in mind, but I feel the initial design was more visually appealing. If you were the teacher, how would you proceed from here?

Well, when you say the initial design was more visually appealing, it might be because changing the skin tone made the colors of the other parts too similar, which might be one of the causes?

IN SUMMARY

If you change the color of a large area, you might need to adjust the colors of the other parts as well.

 ## Be Conscious of the Balance with Surrounding Colors

 In the initial design, the colors of the hair and clothing were decided based on the skin tone. Changing that skin color disrupted the color balance!

When you change a color somewhere, always remember to adjust its balance with the surroundings.

Comparison Before and After Changing the Skin Color

Initial design

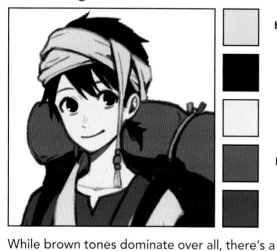

	Hairband
	Hair
	Skin
	Luggage
	Shirt

While brown tones dominate over all, there's a significant difference in brightness between the skin and the other colors, creating a visually clear arrangement around the face.

Revised design

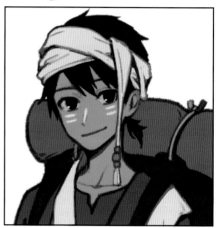

By darkening the skin tone, the difference in brightness with the surrounding colors was eliminated, making the arrangement around the face less distinguishable.

Adjusting the Balance with the Surroundings

Once the colors were changed, the skin tone became more prominent!

Revised color design

The colors of the parts adjacent to the skin changed based on its tone.

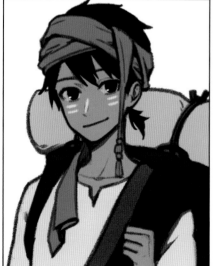

To create a different hue from the skin, the hairband was made complementary blue.

To establish a difference in brightness, the hair was darkened.

Based on the skin tone, the surrounding colors were changed.

To add a contrasting brightness with the hair, the luggage color was lightened.

To establish a difference in brightness with the hair, the shirt was also lightened. The color of the outerwear was changed to black to contrast with the shirt. Being neutral, it doesn't conflict with the adjacent orange and the skin tone.

☰ Add Decorations and Visual Detail

Given the character's role as a traveling merchant selling goods in a market square, it wouldn't hurt to have some more vibrant decorations. Draw inspiration from the clothing designs.

Revised color design

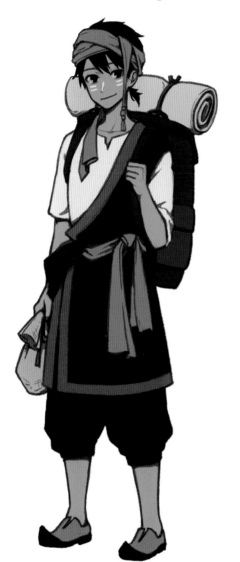

Added decorations

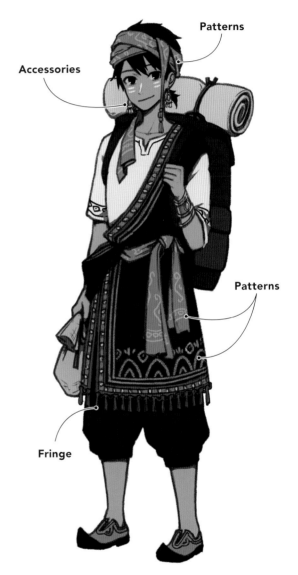

Patterns

Accessories

Patterns

Fringe

➡

It now exudes the right atmosphere all at once!

Adjust the degree of decoration in line with the character's image and setting.

I'm Thinking About What Precise Image to Give Her

 It looks like you're inspired by the fantasy combat manga that's so popular now.

 Yes! All the characters are charming, but the heroines are so cool! I wish I could draw a cool girl like that.

 What kind of persona do you want to portray? Even with the category of "combat manga," there are various types of "coolness."

IN SUMMARY

Specify the image you want to express.

Powerful action

Show the dynamism, speed and movement of the character's pose during action.

A dignified pose with a weapon

Show the calmness before the battle, the tension in the air and the character's serious expression.

Unique weapons

Showcase unique weapons and the character's design itself.

Showing composure during combat

Show the maturity and overwhelming strength of the character.

☰ Expressing a Gap

 I want to capture the drama of intense action. The heroine I like is usually a charmer, but she becomes fierce in battle scenes. I want to draw that kind of gap!

There are various ways to express the gap in a character.

Showing the gap in design

Give a petite, slender character a large, heavy weapon, or give a more diminutive character strong military-colored equipment, incorporating a gap in the character design itself.

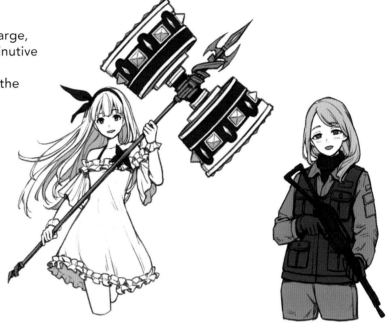

Expressing the gap through methods

Make the character charming and appealing but amplify her cool aura through poses, expressions and effects, capturing the gap.

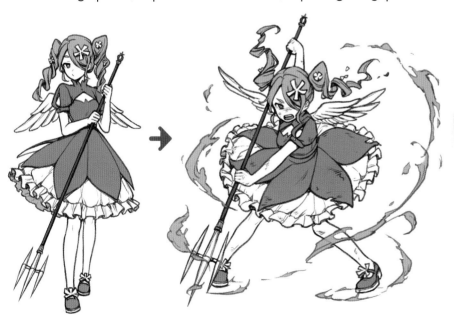

It sounds fun to think about a design with such a gap!

 ## Considering Design and Expression

 To express both cuteness and coolness, I designed the character and weapon!

Character and weapon design

A cheerful and bubbly girl. She's the type to act before thinking things through and, despite her delicate appearance, she's incredibly strong.

Since I want to draw a powerful battle scene, her weapon is a large, heavy axe. To avoid making it look too cute with rounded edges, the design is pointed at the tip.

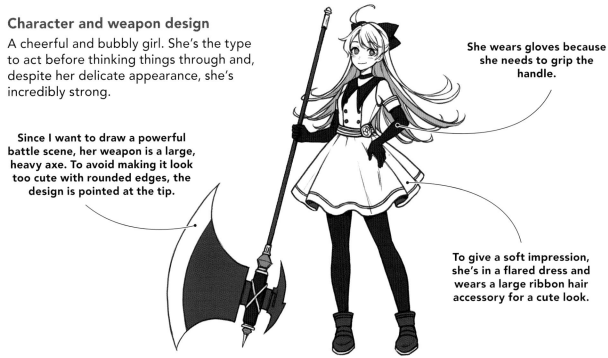

She wears gloves because she needs to grip the handle.

To give a soft impression, she's in a flared dress and wears a large ribbon hair accessory for a cute look.

It's a good design. Next, let's think about the portrayal.

Pose

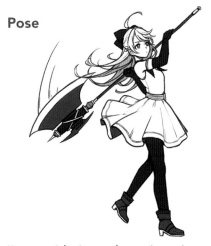

I'm considering a dynamic action combat pose. Given her strength, I'm thinking about her effortlessly swinging the weapon, perhaps just before or after facing an adversary.

Perspective and angle

A direct front view (left) might make it look less dynamic and a bit stiff. Therefore, I'm considering a low-angle shot from the side (right). This perspective can also emphasize the size of the weapon.

≡ Producing Force and Presence

Based on the pose and angle, I decided on the composition.
But it feels like something's missing.

Finally, by adding effects, let's try to bring out more force and presence.

Original illustration

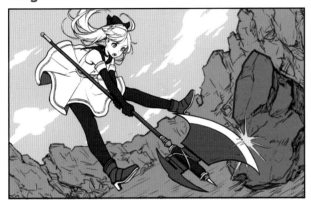

↓

Adding force and presence through presentation

Scattering debris and rock fragments to enhance the feeling of immersion.

Blurring the surroundings to focus on the main character adds depth to the scene.

Adding dust-like effects lends a sense of realism.

Adding perspective to both the character and the background emphasizes the force.

It now truly looks like she's in the midst of battle!

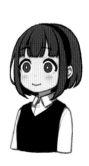

CASE 09 Draw a Character from Provided Information

📃 Understanding the Setting

 So is that illustration for a job?

 Yes, it's a cover for a Japanese mystery novel.

 I'd love to try drawing that someday. Can I watch you work on it?

 I thought you'd ask, so I've already gotten permission. Here's the brief.

Request for the Illustration

Cover illustration for a Japanese mystery novel: *The Case Concludes on the Sofa*. The target audience is men and women in their 30s to 50s. It's not for young readers but for a slightly more mature readership.

Set-up/Synopsis

The protagonist loves alcohol and sleeping in, a slug always lounging on the sofa. However, he has top-notch deductive abilities. One day, a woman comes to him with a request to investigate an incident.

Illustration requirements

- As it's the first volume, the main image should be of the protagonist lounging. The chair is for one person and should have an antique, luxurious design.
- The illustration should have a somewhat mysterious atmosphere and not be too anime or manga-like.
- The character shouldn't look too young; a more mature appearance is required.
- The background is up to you. It can be the room the protagonist is in or the crime scene. No background with just motifs is also fine.

Based on the textual information, you'll develop it into an illustration, right?

I've already read the novel in advance to check any detailed settings.

IN SUMMARY

Translating textual information into an illustration.

Expressing the Character's Personality

 First, I'll think about the protagonist's design. I imagined this character (on the left) after reading only the parts in the text where the protagonist appears.

The "laziness" and "always listless" vibes are clear.

 Yes, but as I continued reading, I found many descriptions about the protagonist's personality and lifestyle. I incorporated these aspects into the character's gestures and expressions (on the right).

Initial image

From the description "A man in his 30s or 40s languidly seated on the sofa" and the brief, I imagined the protagonist.

Reflecting the information

Using lines in the text like "Reading documents is too tedious ... Read them out for me" and "If the shirt's button is missing, as long as the sleeves are on, it's fine," I expressed his inner character.

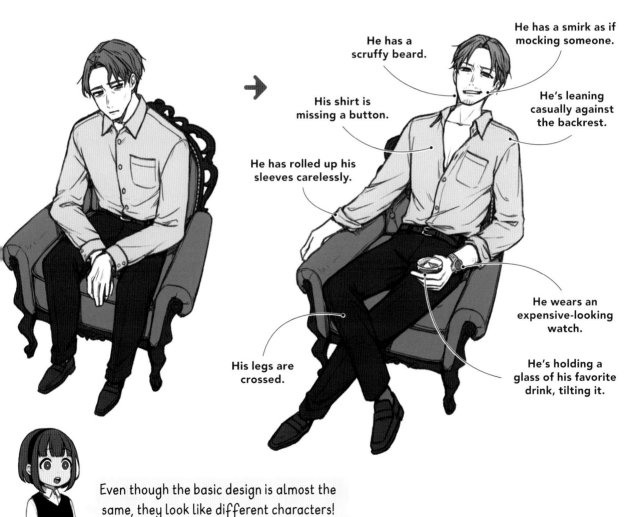

He has a scruffy beard.

He has a smirk as if mocking someone.

His shirt is missing a button.

He's leaning casually against the backrest.

He has rolled up his sleeves carelessly.

He wears an expensive-looking watch.

His legs are crossed.

He's holding a glass of his favorite drink, tilting it.

Even though the basic design is almost the same, they look like different characters!

Considering Composition with Priority in Mind

 Now that the character design is set, I'll think about the composition. As specified, the main focus will be the protagonist seated on a sofa. For the background, I'm considering a floor, a table, and some small items like drinks. I'll be including the following three elements.

The book band and title

タイトル

著者名

+

Character

+

Small items

Be mindful of space at the top, as well as the space for the title and author's name.

Decide on a size and position that makes the character the main focus of the illustration.

Like the table, drinks and floor. They can be placed more freely.

 I'll prioritize the placement of the book band, title and character. The priority for small items is lower than the others.

→

Consider the placement of the title: will the text be set vertically or horizontally?

Placing the title and character
First, decide on the positions for the character, title and author's name. Make sure the title and character are prominent.

Adding small items
Fill in the gaps with the small items. Adjust the character's size and position while checking the overall balance. I've made it slightly smaller and shifted it a bit to the right so it doesn't overlap with the title.

Creating Atmosphere with Touch and Color Scheme

 Keeping in mind the request for a style that's "not too anime or manga-like", I'll bring out the "mysterious atmosphere."

Base color scheme

The painting method lends a pop, anime-like atmosphere. With a white background, the overall impression is bright.

Modifying touch and color scheme

Moving away from the anime style, opting for a moody, thick painting method creates a more mature atmosphere. The overall color saturation is reduced, and the background is given a darker hue.

Final illustration

To avoid the overall look from becoming too dark and dull, I've incorporated vibrant colors such as the blue of the sofa, the brown of the pants and the orange of the glass.

The final image with the book band and title added.

The mysterious atmosphere certainly comes through!

Draw an Illustration of a Seasonal Event

📃 Finding Elements Suited to the Theme

 Do you have another concern?

 Yes, I'm creating an original calendar with my friends. I'm in charge of October, and I'm thinking of going with a Halloween theme, but I can't really imagine a specific illustration.

 I see. In times like that, you should start with a little research. First, gather some references and start sketching Halloween motifs.

 Alright!

Initial sketches

Situations/Activities/Atmosphere
Children in costumes going from house to house, a mysterious yet fun and chaotic vibe.

Motifs
Pumpkins, ghosts, witches, candy, so many choices

Settings
Haunted houses, graveyards

Color schemes
Red and black, orange and blue, monochrome with yellow and purple.

Apart from books and online images, during the season, you can also get inspired by decorations and product packaging.

 For themes that have established images, just incorporating one associated element into the illustration can convey the theme.

How should I incorporate them?

 Here are some ways to incorporate the elements.

Color scheme

Instead of using the cat's intrinsic color, go for a Halloween-style purple-and-orange combination.

Character design

Outfit the character in typical Halloween items like a witch's hat and cape, or bat wings.

Surrounding motifs

Place Halloween-like motifs such as pumpkins, ghosts and bats around the character.

Background/Setting

Draw backgrounds or settings that evoke Halloween, using mansions, cemeteries and spooky moons.

IN SUMMARY

Incorporate elements that evoke seasonal atmosphere and detail.

☰ Innovate with Motif Placement and Size

I'm thinking of placing Halloween-themed motifs around the character!
But I'm not sure where to start.

Depending on what you want to express, when drawing multiple motifs, it's good to arrange them in a way that suggests movement, and to be mindful of the balance in terms of size and quantity.

Examples of Arrangement

Drawing in a circle

This can express liveliness or opulence. It complements compositions where the character the central focus.

Flowing vertically

This can express sensations like falling or floating, representing vertical movement. It complements tall compositions.

Lining them up

While this might not suggest much movement, it prominently displays each motif. Lining them up creates a unified impression.

Variations in Size and Quantity

Size relative to the main subject

When motifs are small, more space or background is freed up (left). When they're large, their presence is accentuated, emphasizing the imagery (right).

Sizes among the motifs

Having a uniform size creates visual unity (left). Introducing differences in size adds depth to the picture and creates contrast (right).

Number of motifs

Using fewer motifs gives a subdued or lonely impression (left). Using many can make the illustration lively, though it might also become overwhelming (right).

 Considering the placement, size and number of motifs, I've drawn the following.

I've focused on typical Halloween motifs like pumpkins, ghosts, bats and candies.

I wanted to capture a lively and fun atmosphere, so I arranged the motifs in a circular pattern and introduced variation in sizes to avoid monotony.

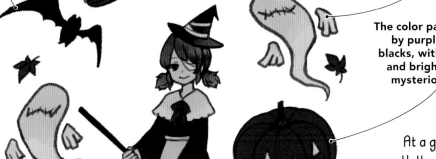

The color palette is dominated by purples, oranges and blacks, with lower saturation and brightness to evoke a mysterious atmosphere.

At a glance, it's clearly Halloween-themed, and it captures the intended ambiance.

The character is a girl dressed as a witch, fittingly holding a broomstick.

💡 **A Bit of Advice**

Using elements for a unique presentation

When drawing illustrations themed around seasons or festivals, you can use unexpected colors to give a unique atmosphere or employ distinctive color schemes to evoke the theme.

Alternative color schemes

Even with uncharacteristic color choices for Halloween, the character and motifs can still convey the seasonal feel.

Alternative motifs

Even if the motif is unrelated to Halloween, by coloring it in a Halloween-esque manner, it can be integrated into the illustration.

CASE 11 Draw an Anthropomorphic Character

 I'll Re-evaluate the Base Character First

 I wonder if the theme for the next assignment, 'Anthropomorphized Animal Character Illustration,' has been decided?

Yes, I'm thinking of going with a crow. ! I love the coolness when they spread their wings to fly, the glossy texture and color of their feathers. I have a vague image of the character in mind.

 Sounds great! Is that the character by any chance?

Yes, but I'm not entirely satisfied with the design. I want to retain the vibe of a cool older sister but also add a bit of a wild atmosphere.

Original base character

Reflecting the image of the crow

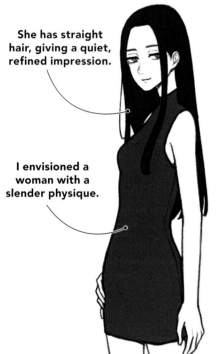

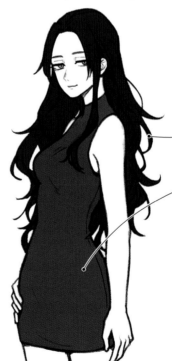

She has straight hair, giving a quiet, refined impression.

I envisioned a woman with a slender physique.

I added more volume over all, varied the length and made the ends flip.

With the crow in mind, I made the physique more substantial.

The face was a bit bird-like, so I kept it, but I think it has a more wild vibe than before!

> **IN SUMMARY**
> Reflecting the animal's qualities on the base character.

Considering the Ratio of the Animal

 From here, I'm thinking of incorporating elements that are reminiscent of a crow to the base!

For anthropomorphism, the impression can change significantly depending on how many human features are retained. It's about the ratio between animal and human. Something like this.

Almost human

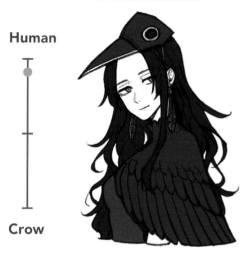

Human

Crow

Keep the base human but incorporate crow-like elements into the clothing and accessories.

Closer to human

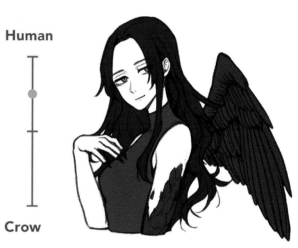

Human

Crow

The base is human, but crow-like parts (wings, claws and skin) are added.

Parts of the body are crow-like

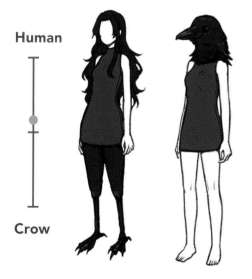

Human

Crow

Instead of adding parts to a human base, the legs or head are made crow-like.

Most of the body is crow

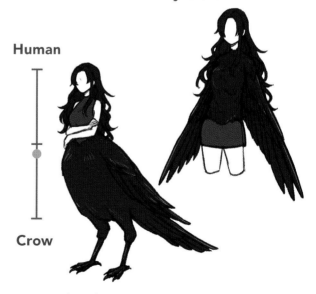

Human

Crow

Either the upper or lower half is crow-like, similar to centaurs or mermaids.

☰ Enhancing the Item's Design Aesthetic

I incorporated crow-like parts and even turned the legs into crow's legs!

It's looking good! By the way, are you sticking with this clothing design?

Right now, the design only captures the anthropomorphism of the crow. I want to express her character and backstory through clothing and accessories!

Character settings

- Among her kind, she holds a noble status and is seen as an elder sister figure.
- She prefers ornate designs over simple patterns.
- She doesn't mind wearing revealing outfits.

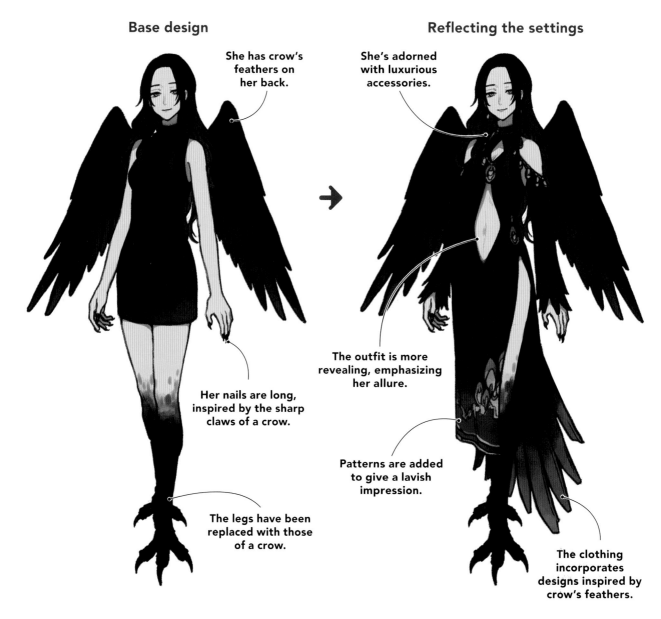

Base design

She has crow's feathers on her back.

Her nails are long, inspired by the sharp claws of a crow.

The legs have been replaced with those of a crow.

Reflecting the settings

She's adorned with luxurious accessories.

The outfit is more revealing, emphasizing her allure.

Patterns are added to give a lavish impression.

The clothing incorporates designs inspired by crow's feathers.

≡ Using Motifs to Express Flow

I completed the character design and tried illustrating her elegantly watching travelers who came to the village from high up in a tree ... but I feel like I couldn't capture the movement I wanted?

The movement of the surrounding crows might look a bit monotonous and unnatural. Should we try adjusting with movement flow in mind?

Original illustration

The size and angles of the background birds are similar, making the movement seem monotonous.

Changing the size and angle of the crows

Create depth and dimension by varying sizes and adding to the frame. Changing the angle of the crows and unifying their direction helps in expressing and suggesting flow.

Completed illustration

With the flow of the crow's movement, the unnatural pose has been eliminated!

 Draw a Music-Themed Illustration

I'm Thinking About a Composition that Illustrates Musical Qualities

 Oh, you're drawing a new illustration.

Yes! I've been drawing inspired by a song I've recently been into! It's a calm and quiet song overall, but the delicate piano accompaniment and the clear singing voice are so good. Umm ... can I get some advice this time too?

 Of course. It would be nice if you could express the atmosphere of the song in the illustration.

A rough sketch inspired by the song
Here, two close friends occupy a quiet space, one singing the other accompanying.

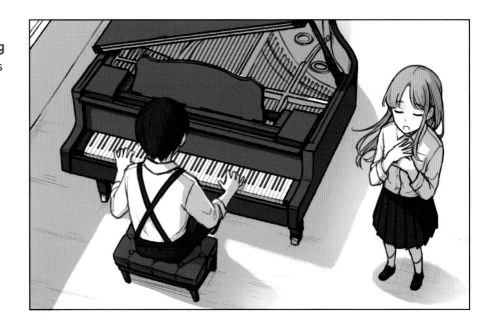

 It seems like it could capture a calm atmosphere, doesn't it? By the way, the face of the character playing the accompaniment isn't visible. Was that intentional?

I actually wanted a composition where both of their faces were visible, but it didn't work out.

 In that case, think about a composition showing a musical performance where the characters' faces are visible.

IN SUMMARY
Include the instrument while also showing a character's face and attitude.

 By changing the viewpoint and angle as well as the direction of the singing character and the piano, you can have a composition where both faces are visible.

Oblique bird's-eye view from the opposite side

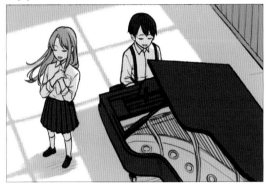

Change the direction of the singing character so that both faces are visible. The piano and the character are well-balanced.

From the side

Both of their profiles are visible, so it's an easy composition for suggesting a quiet, calm atmosphere. You can show the background as well.

Low-angle shot

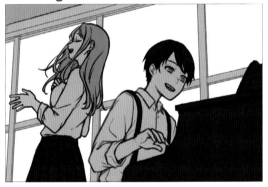

The atmosphere changes completely depending on the composition!

A composition close to the characters to mainly show their expressions and gestures. However, if it's too close, you might not recognize it as a piano.

 A Bit of Advice

Unifying size and perspective

When drawing motifs like a piano that have a fixed size, be careful about their spatial relationship to the character (above). When placing multiple characters or motifs on the same screen, in addition to size, also match the perspective. If the perspective isn't consistent, it won't look like they're in the same space, and the balance will feel off (below).

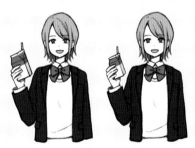

Holding a juice box or carton. The left is the appropriate size, but the right is small.

If there are motifs with competing perspectives on the same screen, they won't look like they're occupying the same space.

 ## Devise a Way to Guide the Viewer's Gaze

 I chose the side-view composition that best matched the song's mood and added a large window to depict light pouring in. It's supposed to have an abandoned vibe, so I wish I could've added some dust-covered furniture.

Why did you decide against drawing the furniture?

 I did consider it ... but the key elements are the two characters and the piano. With so many elements, I felt that adding furniture might make the main subjects less prominent.

Only added the window

Placed furniture in the foreground

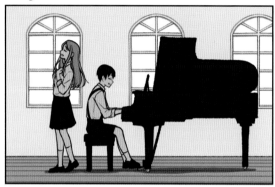 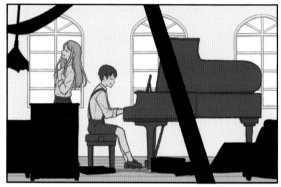

 You can change the size or position of the furniture to create a composition that draws the eye to the protagonists.

Composition where the gaze drifts easily

Composition conscious of guiding the gaze

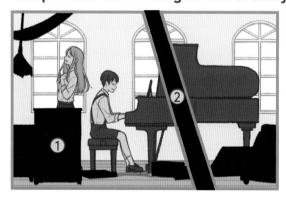 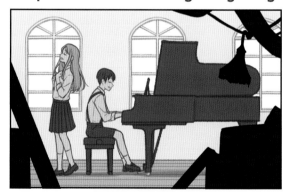

The characters and piano, labeled 1 and 2, are overshadowed. Moreover, the placement of 2 divides the screen, causing the viewer's gaze to wander.

Furniture is arranged so that there's space around the main subjects. By drawing the foreground furniture larger, the distance from the main subjects is expressed, and the room's side-view depth is suggested.

 So, I should create a space that draws the gaze to the characters and the piano!

⊜ Achieving a Sense of Transparency with Color

 Once the composition is settled, next is the coloring.

Yes, but when I tried placing colors, it deviated from the song's image.

 Perhaps you're getting too caught up in the abandonment theme. If you prioritize transparency, how about this approach?

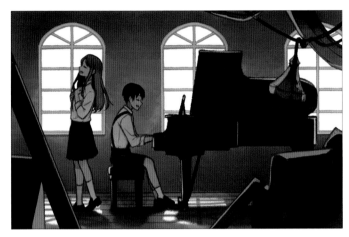

Initial and revised color palette
While I chose heavier sepia tones, they failed to capture the singer's voice and its sense of transparency.

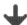

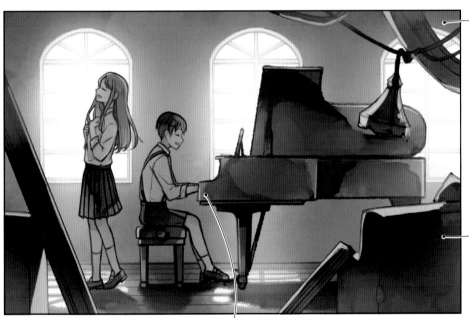

By adding soft light from the window, I've created an airy ambiance.

Shifting from an overall sepia tone to cooler hues, which are easier for conveying transparency.

Maintaining the overall contrast of light and shadow, and adding bright, vivid colors to illuminated parts enhances the sense of transparency.

I've managed to capture the desired sense of calm, transparency, and delicacy!

CASE 13 Draw a Character with a Captivating Expression

☰ Adding Gestures That Match the Expression

 Having learned about the effects of lighting, I tried backlighting a previous illustration I made, but the character ended up looking a bit scary. Ideally, the theme was 'a girl's smile on Christmas night when the person she was waiting for finally appears'.

Indeed. Though it should be a happy expression, the one on the right seems angry.

Original illustration **Changed to backlight**

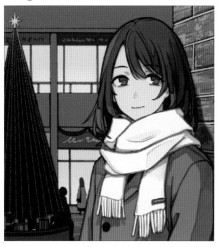 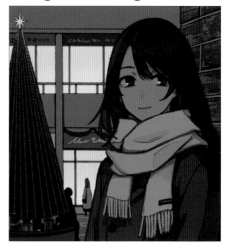

 Hmm ... Perhaps the expression is too stiff? I tried to correct it, what do you think?

Original illustration **Corrected expression**

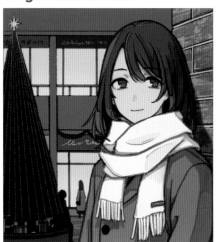

Compared to the previous one, the expression is softer and conveys richer emotion. Now, how about adding a gesture to enhance it even further?

 A gesture?

Even with just the facial expression, a character's emotions can be conveyed. But by adding gestures, like touching the face with a hand or tilting the head, the portrayal can become more natural and lively.

IN SUMMARY

Showcasing expressions by adding gestures.

Examples of Gestures Matching Expressions

Pondering
Rest a hand on the chin and tilt the head.

Joyful laugh
Wipe away a tear with a finger and slightly lift the chin.

Embarrassed and shy
Press both hands against the cheeks and point the chin downward.

 I added gestures! I tried to depict the joy of seeing the person she's been waiting for.

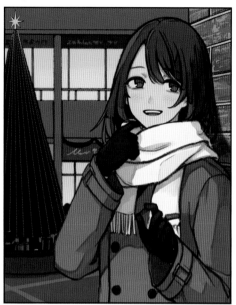

Illustration with added gestures

She's raising her left hand as if to wave. At the same time, she's lowering her scarf to show her face and lifting her head.

Just a few additional touches changed the whole impression.

 Using Light and Effects for Dramatics

 As I initially intended, I tried adding backlighting! The light source is from the buildings in the background.

Illustration before modifying the expression

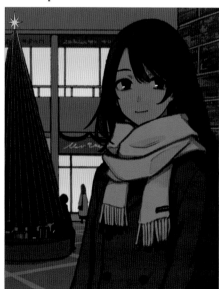

Illustration after modifying the expression

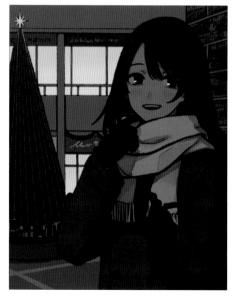

With the corrected expression and gestures, even with the backlighting, the joyful emotions come through.

 I'm thinking of further arranging the overall color scheme and effects to match the backlighting!

Added lighting effects

To emphasize the backlighting, I added more lights in the background. By incorporating various colored lights like yellow, orange and light blue, the scene becomes more vibrant.

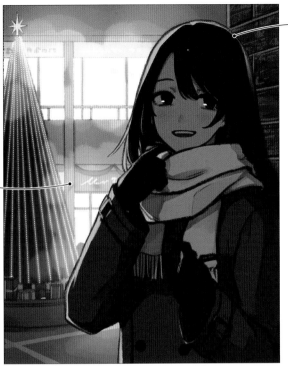

I added highlights to the character to represent the light seeping through. I went with distinct highlights, contrasting them with the soft background light.

With the lighting effects, it now has a more dramatic impression!

Coloring and effects

To capture the essence of winter, I added blurry snow. With backlighting, brighter color effects are more pronounced than with direct light in addition to introducing movement to the scene.

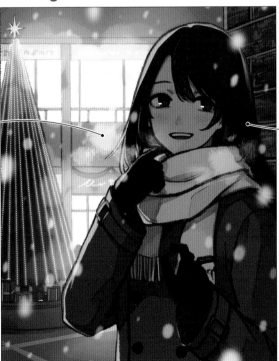

Matching the bright and vivid background, the colors of the character were also changed to something more bright and vivid.

The illustration now conveys the surrounding ambiance and atmosphere beautifully.

CASE 14　Draw an Illustration That Tells a Story

📑 Increasing the Design Density

I just finished watching "Mercuria at the End." The moving portrayal of humans and cyborgs helping each other in a world on the brink of destruction was really impressive!

 Their poignant relationship is quite the talk. It seems that your illustration was heavily influenced by it.

 Was it that obvious?

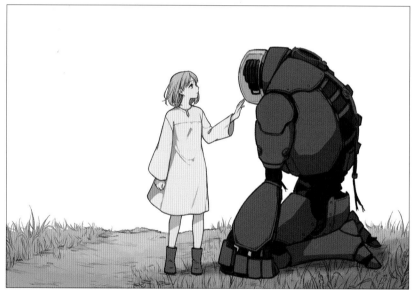

The story and illustration

A scene from a story where a robot, which has been protecting people in a land turned barren from war, ceases to operate once the countryside recovers.

 The illustration certainly conveys this notion of the poignant and beautiful relationship between humans and machines.

 Thank you! I plan to delve deeper and reflect the story more in the illustration!

 With some creative expression techniques, it seems you could enhance its appeal even more.

IN SUMMARY

Refine the setting to suggest the story through the illustration.

 Since the background is simple, I'm thinking of enhancing the design density to make the main character more captivating on its own!

Original illustration

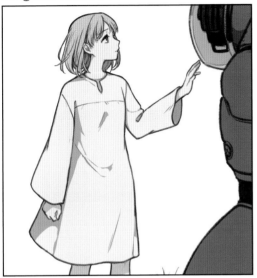

Added elements

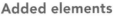

I imagined embroidery using naturally dyed threads and added patterns to the clothing. I also added a crown of grass and a bag made from animal hide. Given the setting of a world where civilization hasn't fully revived, I've avoided using brightly dyed clothes or flashy decorative accessories.

Original illustration

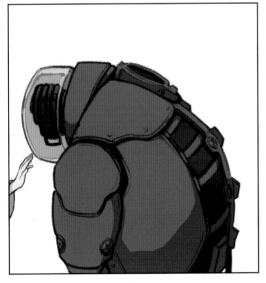

Added elements

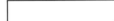

To show that a considerable amount of time has passed since the robot stopped functioning, I showed moss and other plants growing on it. To signify that it's completely inoperative and not dangerous, I've placed a small bird on it as well.

I've taken care to ensure both the girl and the robot fit this world and setting!

 ## Adding the Effects of Light, Shadow and Texture

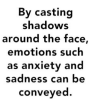 I'll depict light and shadow to further enrich the visual information. By casting shadows on the character, I'm also aiming to emphasize their poignant relationship.

You're deliberately employing the effects of light and shadow, aren't you?

Added shadows

By casting shadows around the face, emotions such as anxiety and sadness can be conveyed.

Capitalizing on the rich natural setting, I've also drawn the shadow of a large tree that's presumed to be nearby.

Even with a simple background, the scene is becoming more visually compelling.

 To enhance realism, I'll delve into depicting textures.

Illustration with added shadows

Further textural additions

I've added scars and rust to the robot, in contrast to the youthful presence of the girl.

Adjusting the Overall Balance

 It seems to have deviated a bit from the initial image. It should have improved, but ...

As you delved into the details, the overall balance got disrupted. Once you've done a significant amount of detailing, it's good to step back and adjust the whole picture.

Before adding textures

After adding textural details

With added details throughout, compared to before the detailing (on the left), the distinction between illuminated and shadowed areas has diminished, leading to a uniformity and a lack of contrast. By detailing even the grass in the background, the backdrop becomes overly emphasized, compromising the sense of depth and atmosphere.

Adjusting balance

Adjusting saturation and brightness to tone down the overly dark background colors.

Making the difference between illuminated and shadowed areas more distinct.

Detailing the foreground grass a bit more and creating contrast with the background to convey depth.

I feel I've crafted a scene that aligns with the narrative's setting!

CASE 15 — Draw an Illustration That Conveys Point of View

Gathering Materials

 My final project is due. Have you decided on the piece you want to create?

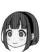 Since I want many people to see it at the exhibition, I'm thinking of making a lively and fun illustration with a festival theme. Right now, I'm gathering materials and designs that match the theme and brainstorming ideas!

 Given that it'll take longer than usual to create, it would be good to clearly note the initial image you have in mind.

Idea sketches

Character design
A girl who loves festivals placed at the front of a procession.

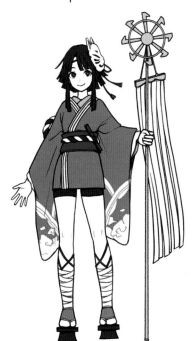

Festival-like motifs
Lanterns, water balloons, fans, fireworks, umbrellas and portable shrines all work.

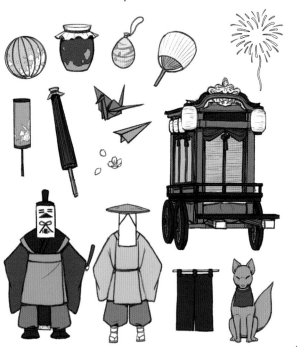

> **IN SUMMARY**
> Collect motifs that fit the scene and solidify the axis.

☰ Decide What You Want to Showcase

> I intend for the girl to be the main character, but I also want to clearly showcase the surrounding motifs and lively atmosphere ... I'm unsure about the composition.

You want to highlight both the character and her world. Given the many motifs, first decide how to position the character, the orientation of the composition and the ratio of showcasing the character vs. motifs.

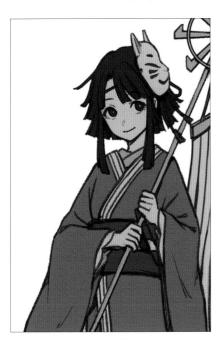

Waist-up vertical composition

Showcases the character's expressions and gestures, but due to limited space, it's harder to incorporate motifs and backgrounds. Display ratio is Character 9: Motifs 1.

Full-body vertical composition

Displays the character's full body or vertical movements. Can also incorporate long objects like umbrellas or flags. Display ratio is Character 7: Motifs 3.

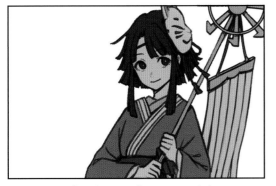

Waist-up horizontal composition

Similar to vertical, this approach makes it easy to showcase the character. More space is available compared to the vertical composition. Display ratio is Character 8: Motifs 2.

Full-body horizontal composition

Given the smaller character, more motifs can be included while depicting horizontal movements like walking or running. Display ratio is Character 6: Motifs 4.

≡ Highlighting the Protagonist

I think I'll go with a full-body horizontal composition! I've initially arranged the character and motifs from right to left.

Positioning of the protagonist and motifs

By overlapping multiple motifs like the fireworks, lanterns and the main character with the crowds and the bridge's railings, I've created a sense of depth.

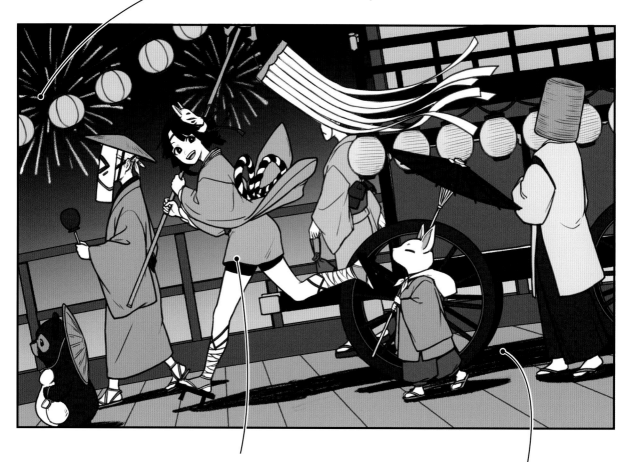

In contrast to the surrounding crowd, by showing the protagonist dashing down the street, her lively character and energetic nature are showcased.

To introduce motion to the scene, the bridge and motifs are positioned diagonally.

 While the festive vibe is evident, the scene seemed cluttered. The protagonist isn't easily visible, so I've reworked the composition.

Revised composition to highlight the protagonist

Due to the placement of the crowd, the right side felt cramped. To balance it out, I've added motifs to the foreground on the left.

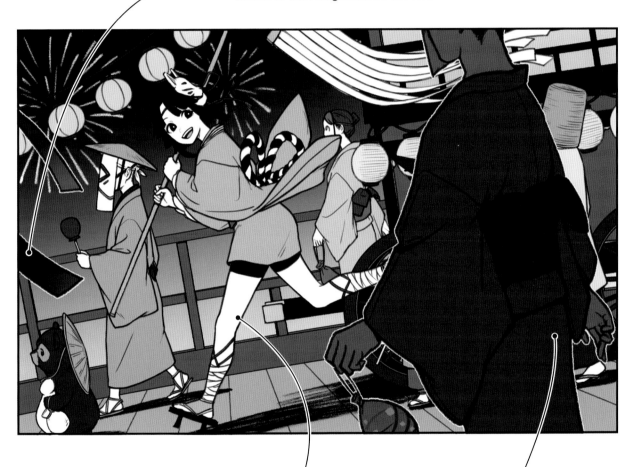

Since the protagonist was getting overshadowed, I've increased her size for more presence.

To draw the eye toward the protagonist on the left, I've positioned backlit figures on the right.

 ## Deliberate Color Choice

 With so many motifs, I wanted to avoid clutter and ensure the protagonist isn't overshadowed. After finalizing the colors, shading will be added, followed by detailed touches to complete the piece.

Protagonist-focused coloring and finishing

To highlight the protagonist, the
background colors are subdued.

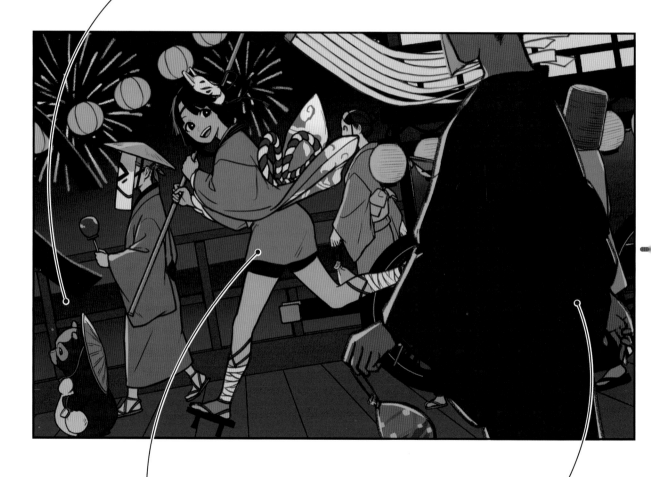

Since the overall color palette reflects a
warm and festive tone, the protagonist is
rendered in cooler tones to stand out.

Foreground motifs and figures are
darkened with less saturation, reducing
their contrast to ensure they don't
overshadow the main character.

Though the background colors are
subdued, the luminous lanterns are
rendered in vibrant shades.

A strong contrast between the areas of light
and shadow brings out the depth.

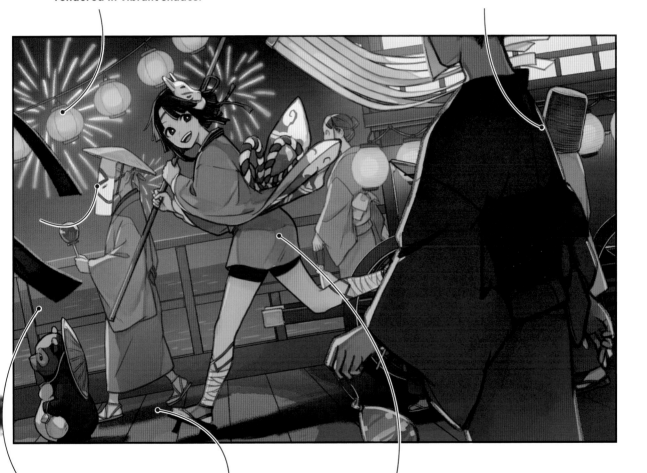

To achieve an airy
ambiance that fades
into the distance, a
soft light is applied.

By shading the
bridge, the degree of
detail is increased.

More detailed layering is
applied to the protagonist
to make her stand out all
the more.

It's lively, and the protagonist
is clearly highlighted.

"Books to Span the East and West"

Tuttle Publishing was founded in 1832 in the small New England town of Rutland, Vermont [USA]. Our core values remain as strong today as they were then—to publish best-in-class books which bring people together one page at a time. In 1948, we established a publishing outpost in Japan—and Tuttle is now a leader in publishing English-language books about the arts, languages and cultures of Asia. The world has become a much smaller place today and Asia's economic and cultural influence has grown. Yet the need for meaningful dialogue and information about this diverse region has never been greater. Over the past seven decades, Tuttle has published thousands of books on subjects ranging from martial arts and paper crafts to language learning and literature—and our talented authors, illustrators, designers and photographers have won many prestigious awards. We welcome you to explore the wealth of information available on Asia at www.tuttlepublishing.com.

Published by Tuttle Publishing, an imprint of Periplus Editions (HK) Ltd.

www.tuttlepublishing.com

ZERO KARA UMIDASU CHARACTER DESIGN TO HYOGEN NO KOTSU
© 2021 Shun Akagi
© 2021 GENKOSHA Co., Ltd.
English translation rights arranged with GENKOSHA CO., LTD.
through Japan UNI Agency, Inc., Tokyo

English translation © 2024 by Periplus Editions (HK) Ltd

Library of Congress Control Number: 2024931686
ISBN 978-4-8053-1802-7

26 25 24 10 9 8 7 6 5 4 3 2 1

Printed in China 2404EP

Distributed by

North America, Latin America & Europe
Tuttle Publishing
364 Innovation Drive
North Clarendon
VT 05759-9436, USA
Tel: 1 (802) 773 8930
Fax: 1 (802) 773 6993
info@tuttlepublishing.com
www.tuttlepublishing.com

Japan
Tuttle Publishing
Yaekari Building 3rd Floor
5-4-12 Osaki, Shinagawa-ku
Tokyo 141-0032
Tel: (81) 3 5437-0171
Fax: (81) 3 5437-0755
sales@tuttle.co.jp
www.tuttle.co.jp

Asia Pacific
Berkeley Books Pte. Ltd.
3 Kallang Sector #04-01
Singapore 349278
Tel: (65) 67412178
Fax: (65) 67412179
inquiries@periplus.com.sg
www.tuttlepublishing.com